WINSFORD
THROUGH TIME

Paul Hurley

AMBERLEY PUBLISHING

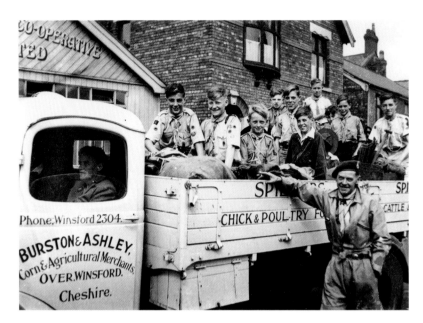

Wharton scouts on the back of a lorry to be driven by Percy Clutterbuck in the 1952 Winsford Carnival procession. Oh, the innocence and freedom of youth!

First published 2009

Amberley Publishing Plc
Cirencester Road, Chalford,
Stroud, Gloucestershire, GL6 8PE

www.amberley-books.com

British Library Cataloguing in Publication Data.
A catalogue record for this book is available from the British Library.

ISBN 978 1 84868 796 7

Typesetting and Origination by Amberley Publishing.
Printed in Great Britain.

Acknowledgements

I would like to thank Cheshire West and Chester Council for permitting me to use photographs from their archive at the Salt Museum and the help of the curator Matt Wheeler, and I would like to thank Richard Rawlinson for the use of his photographic archives. Likewise, Mary Curry, secretary of the Winsford Local History Society, for her invaluable help and the loan of photographs from the society. Peter Atherton, James Oakes and Lillian Platt for their kind offer of old photographs, Sue and Sarah at Amberley and my wife Rose for her patience and understanding during the lengthy compilation of this book.

About the author

Paul Hurley is a freelance writer and published author who has a novel, newspaper, magazine and book credits to his name. He lives in Winsford with his wife and has two sons and two daughters.

Northwich Through Time was published by Amberley in August 2009. His next book will be *Mid-Cheshire Villages Through Time*.

Introduction

Salt had been mined by the Romans from beds beneath mid Cheshire and it was rediscovered in 1670 by employees of the local Smith-Barry family who were digging for coal in the grounds of their house, Marbury Hall. A 'salt rush' then started to the detriment of the town; when rock salt mining gave way to liquid brine pumping the town suffered grotesque subsidences. Winsford, sitting as it did on extensive salt beds, had seen salt extracted since the seventeenth century, but initially only for use as salt licks for animals! Another 'salt rush' started with the building of salt works along both banks of the River Weaver. By 1860 500,000 tons of white salt left the town by boat for Liverpool and onward across the world.

The area had 416 salt pans, each with its own chimney belching acrid smoke, and by the end of that century Winsford was the largest salt producing town in Britain. Fortunes were made, mansions built and the working class worked under the most awful circumstances. There were salt magnates like Falk, Furnival and Verdin but in 1915 there were around 296 individual salt proprietors in Winsford. Some became fabulously rich, some not so. Herman Falk was German and, like echoes of today perhaps, he imported Polish and other foreign workers to work for him. He housed them in a poverty stricken bass town at Meadow Bank where houses were made of bass, the waste cinder product from the cheap coal that was used under the salt pans. All of this meant that Winsford had an interesting history and although the town has changed many times over the years a lot of the buildings remain. Not as damaging as the subsidence at Northwich, Winsford still had its share, and, like at Northwich, many buildings were constructed with the possibility of further subsidence in mind.

The villages of Winsford, Wharton and Over were amalgamated in 1894 when Winsford Urban District Council came into being. A declining Victorian working town has become one of the most modern and pleasant industrial and residential areas in the Northwest. The town centre has reinvented itself many times and at the time of going to press is about to do so again as planning permission has been given to demolish and rebuild most of the town centre now known as Winsford Cross!

When I was invited to contribute a few books to this very popular series I was more than happy to do so, a book of this nature is aimed at all types of readers. If you are looking for a turgid scholarly local history tome, then look elsewhere. If you urgently need to know the difference between the

various types of bricks used or the constituent difference between marl and gypsum, then look elsewhere. If you want a book to enjoy and peruse over and over again then it is here. Take a walk through Winsford from Over to Wharton and use the book as a guide to what has changed and how. You don't even need to know the town or live here as the photographs speak for themselves and are interesting in their own right.

As well as the 'then and now' photographs you will find researched captions between each pair. I have tried to find little known snippets of information where possible. For instance, most people have heard of Lord Bradbury of Winsford and how he was the Joint Permanent Secretary to H.M. Treasury, how his signature was on the bank notes and they were known as bradburies and that he was born in Crook Lane. But how many people know that he was also the Principal British Delegate to the Reparation Commission at the end of the First World War? The draconian demands made of Germany by this commission helped Hitler to gain support and power which subsequently led to the Second World War.

So enjoy these comparisons with times past, drift back to the days of poverty and hardship, to immense wealth and strict class distinction. Let the book take you through time and, most importantly, enjoy it.

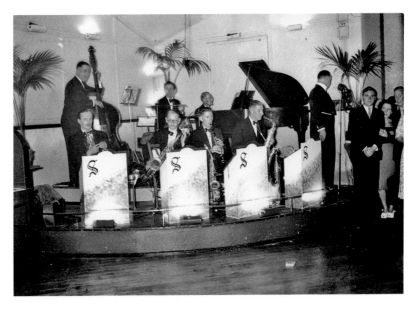

The Eric Marsden band. photographed in 1948 at the Strand Ballroom in the Market Place. This band were regulars at this popular night spot which ended its life as Mr Smiths Club, a far less select venue by then with its strippers, Jack Whittick and his three legged dog, chicken in the basket and soggy carpets! But happy memories of old Winsford all the same.

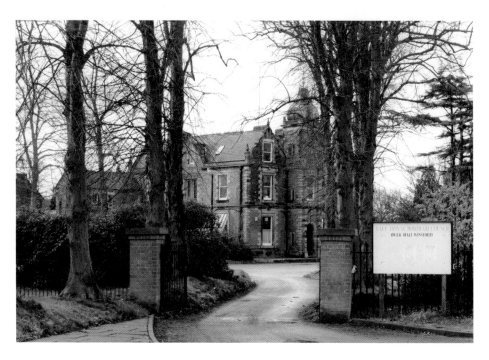

Over Hall 1970s and 2009

Over Hall was built by the Haigh family, owners of the Over Cotton Mill which burnt down in 1874 with the loss of 8 lives and putting some 300 out of work. The insurance had lapsed shortly before the fire, putting the Haigh family into bankruptcy. The Hall was later purchased by salt magnate Reginald Barton and taken over by the army in the Second World War. After the war it was given to the council as the Council Offices. It has now been replaced with a housing estate.

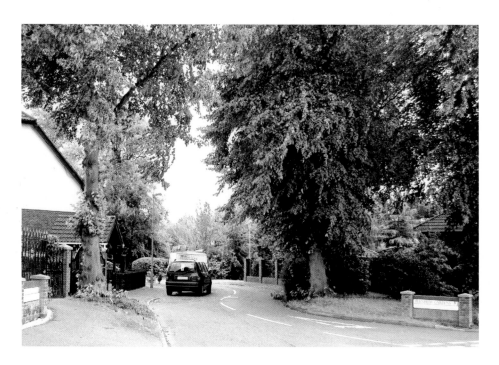

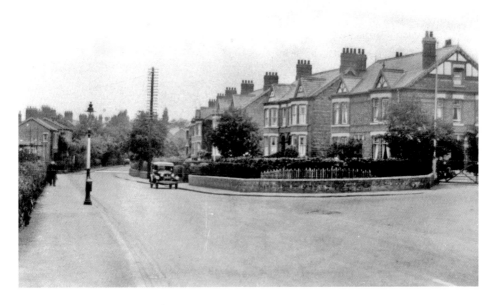

Swanlow Lane, 1920s and 2009

Swanlow Lane at the top of Winsford boasts the more exclusive houses of the period. At the turn of the last century when most of these houses were built the lower reaches of Winsford had many salt works with their chimneys emitting noxious fumes. Hence the managers and owners preferred to live at the top of the hill away from the smells and fog.

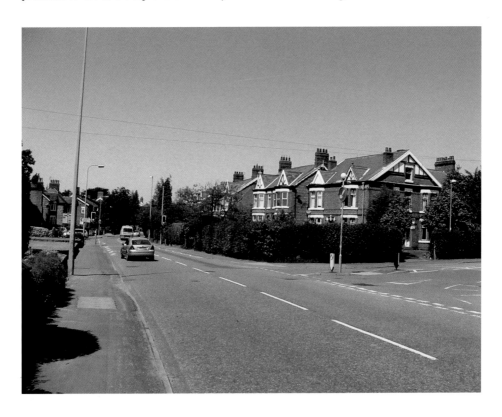

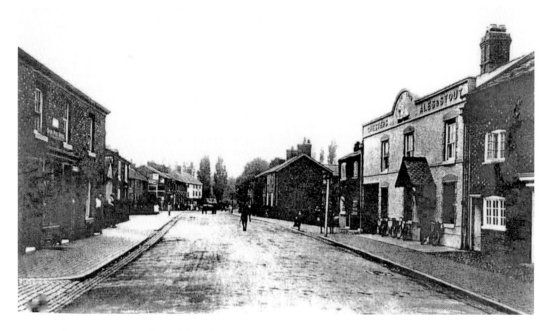

Delamere Street, The White Lion Pub, 1920s and 2009

This ancient thoroughfare of Delamere Street was the centre of the ancient borough of Over. The White Lion pub existed from 1810 until it was demolished in the early 1960s when a new one was built and is still open today at the junction with Saxon Crossway. Originally it backed on to farm land leading down to New Road and the salt mines, now that land contains the Grange Estate.

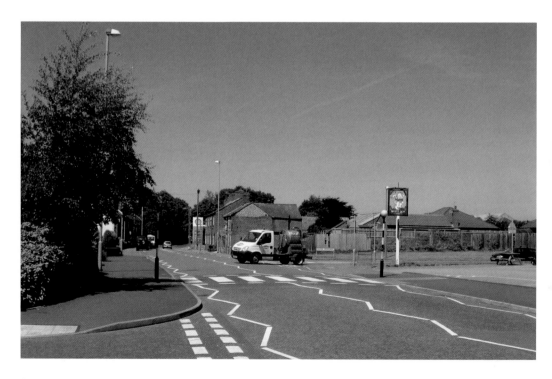

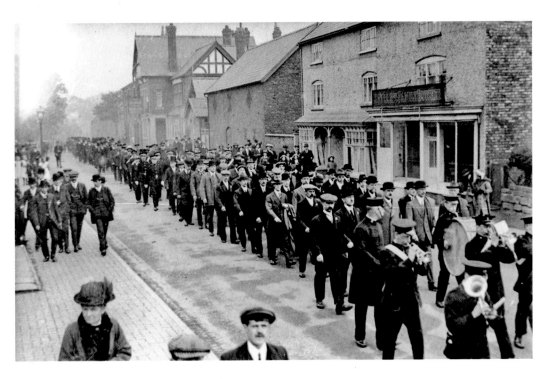

Delamere Procession, 1911 and 2009

Another procession in Delamere Street passing the George and Dragon and a butcher's shop, this one is the coronation procession in 1911 led by Winsford's Salt Union band. In the modern photograph buildings have been demolished to make way for the pub's car park.

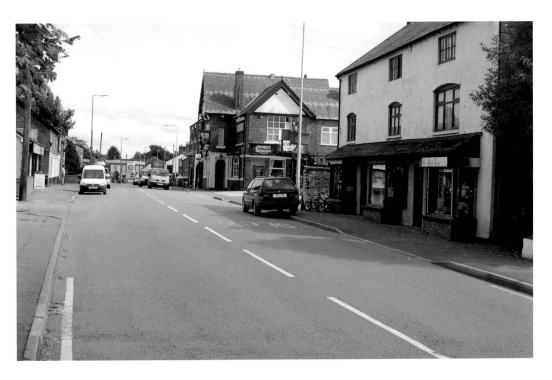

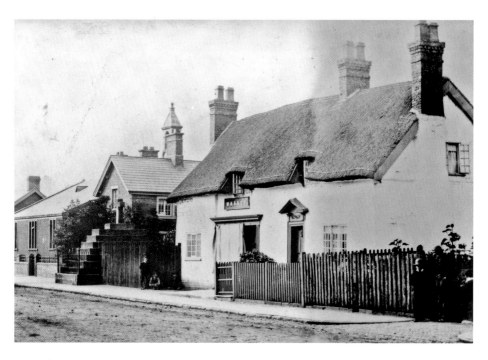

Over Cross School and Cross in Delamere Street, 1920 and 2009

The old photo shows the seventeenth-century thatched cottage that was demolished in 1972. There were two ancient crosses in Over but they were removed in the early 1800s. The Saxon cross twixt the cottage and the school was built in 1840 and contained a lock-up. The schools were built in 1840 at a cost of £500 for use as the Market Hall; they were bought by Lord Delamere in 1858 and converted into a school.

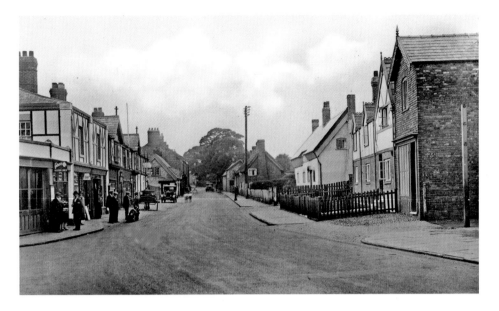

Delamere Street, 1920 and 2009

We now stand on the Over Square roundabout and look into Delamere Street. The 1920s view has changed little from today, the buildings in the foreground are still there but the large white cottage on the right was demolished and became Dickinson's car showroom and petrol station, the latter remains but a Spar store has replaced the car showroom.

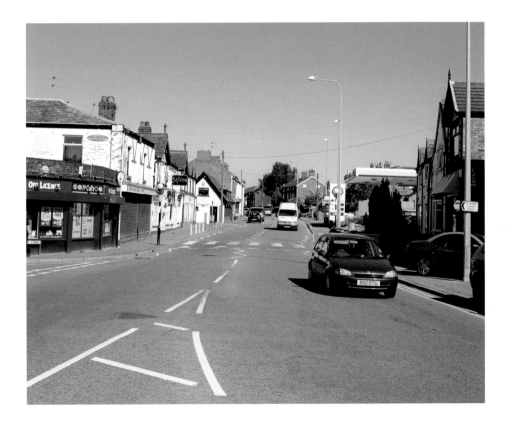

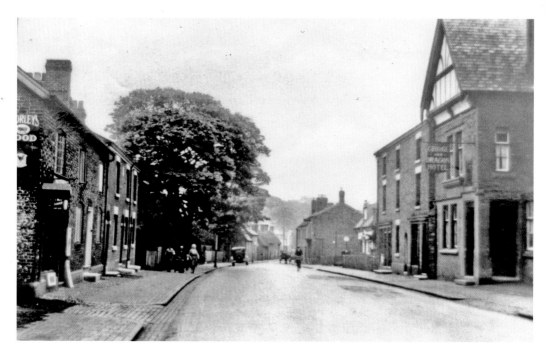

The George and Dragon, Delamere Street, 1920-25 and 2009

This pub built in the early 1800s became the administrative centre of Over. It was built with a large room upstairs to house civic ceremonies such as the court for the Lord of the Manor. Lord Delamere held this title for much of the time and was the owner of the pub until 1882. Before 1894 the mayor of Over was also a justice of the peace and minor felons were locked in the cellar until the Over Cross lock up was erected in 1840.

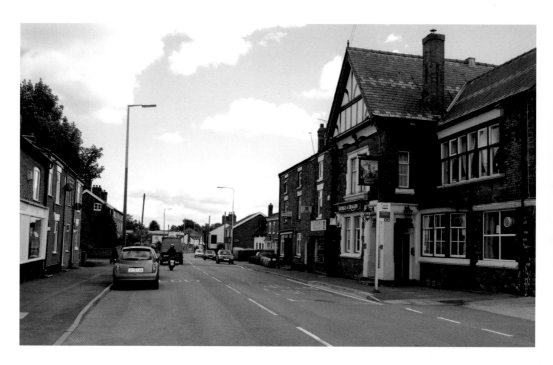

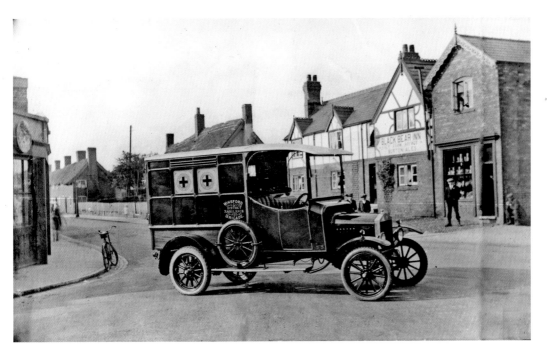

Winsford Ambulance Brigade Ambulance by the Black Bear, 1910-1920 and 2009

I have researched this photo and can say that the ambulance is not from the St John's Brigade, it could be a facility provided by the town council during the first war. I have included it because it is an excellent photo of the vehicle and the area. The Black Bear behind the vehicle has on the wall 'Free from Brewery' (now meaning a free house). It had, however, been purchased in 1894 by John Armitage, owner of the Over Brewery next door!

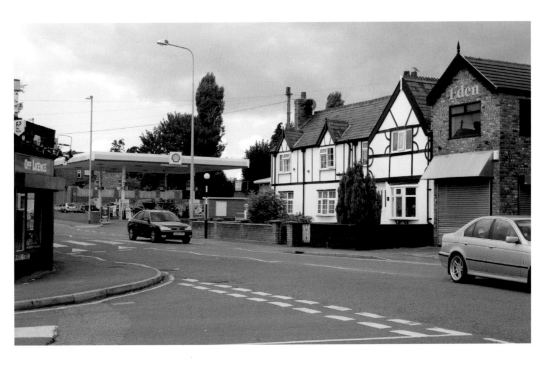

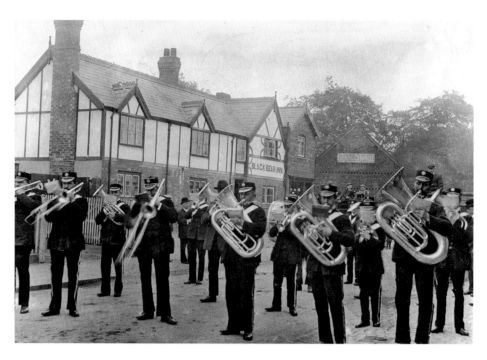

Over Silver Band by the Black Bear, Unknown Date and 2009

This old sepia photograph depicts the Winsford Silver Band playing outside the Wheatsheaf, now Saxons. Behind it can be seen the Black Bear pub which opened in 1810 and closed in 1923. It is now a house.

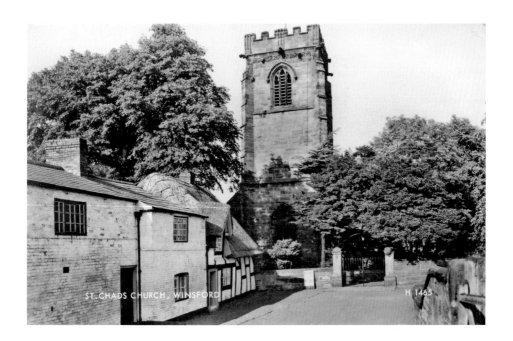

St Chad's Church, Undated and 2009

The church originates from the fourteenth century but could have had earlier origins. It is situated down a lane and away from the main village of Over. In the village were two stone crosses. Now – apart from a small piece in the church – long gone they may well have marked the spot where St Chad preached and baptized people in the nearby stream.

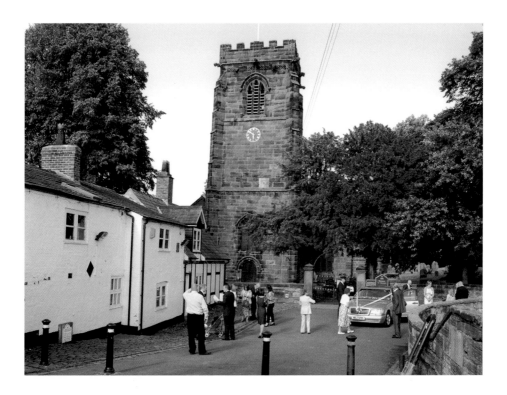

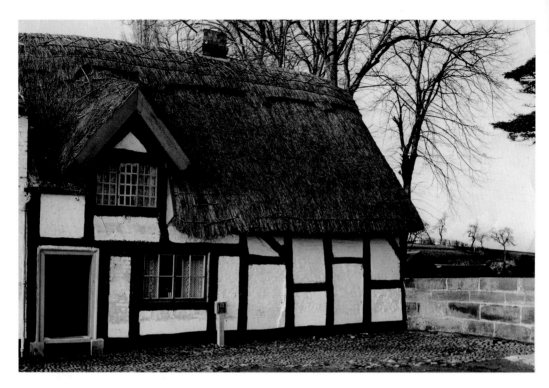

The Bluebell Inn by the Church 1957 and 2009

The black and white cottage was once known locally as the Bluebell Inn but its proper title was simply The Bell. It existed as a pub from 1810 to 1930 when it was forced to close. The last landlord, William Mainwaring, received £305 compensation and the brewery, £900. The white building in the modern photo is a rebuild as the original burnt down some years ago.

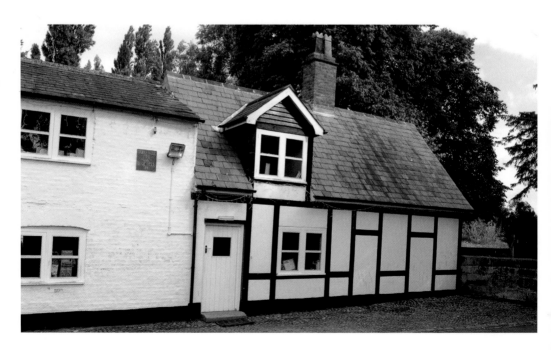

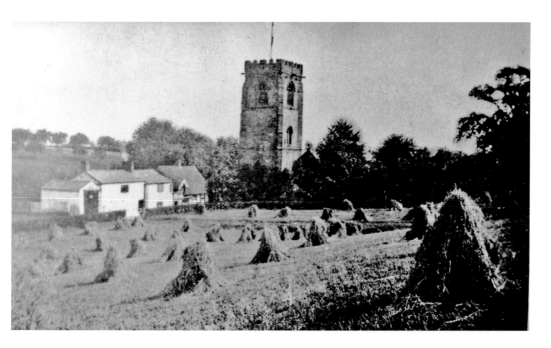

St Chad's Church from the Harvested Field, 1904 and 2009

A last look at this most famous of Winsford landmarks. A summer shot from the cornfield after the corn has been bound and stooked to dry and await collection. As can be seen in the old and new photographs, little has changed in the area. The building on the far left was a garage for the horse drawn hearse. The church was extended in 1926, the fourteenth-century east window being retained. The buildings now house a children's day centre.

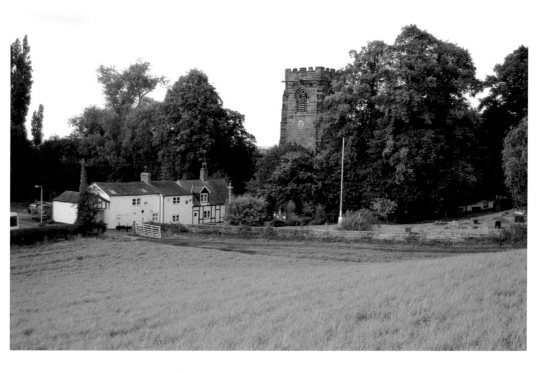

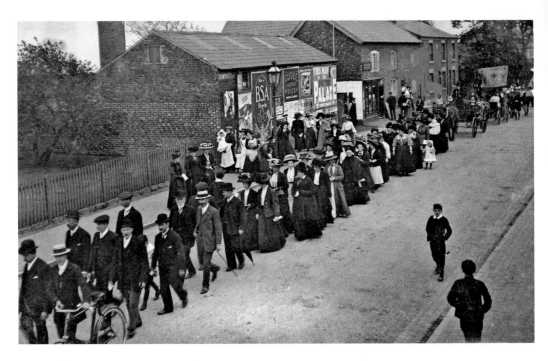

Delamere Street, 1910 and 1920

Looking along Delamere Street towards Over Square at the buildings opposite The George and Dragon pub, a pre First World War parade is passing with the marchers in their Sunday best. Nannies with children, a horse drawn coach and a banner can be seen. The wall of the building is covered in period adverts for cycles, metal polish and the Picture Palace cinema in Market Place etc. Some of the buildings remain but the building with the adverts has been replaced.

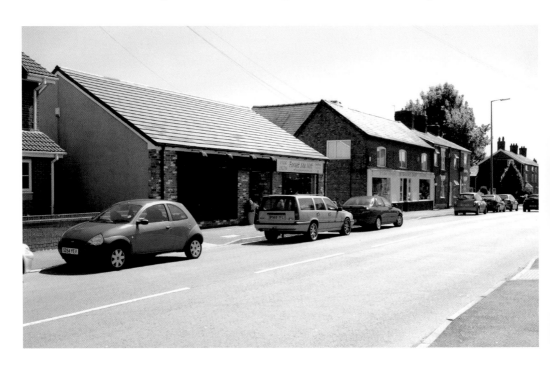

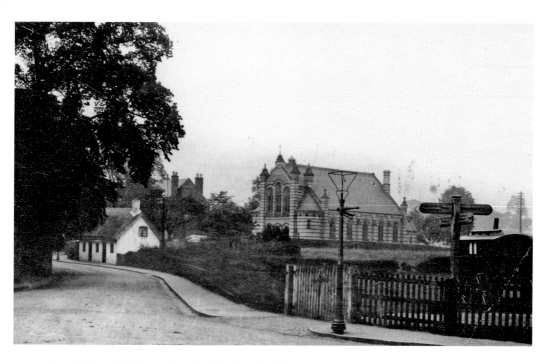

Over United Reform Church, 1900 and 1910

Here we look into Swanlow Lane at the United Reformed church with its unusual brickwork in the centre. The church was built in 1865 originally as a Congregational chapel in what was known locally as a 'streaky bacon' look, which the acclaimed historian Nikolaus Pevsner described as simply ugly! It is still very much in use and an integral part of the Winsford scene, I doubt if it could now be called ugly!

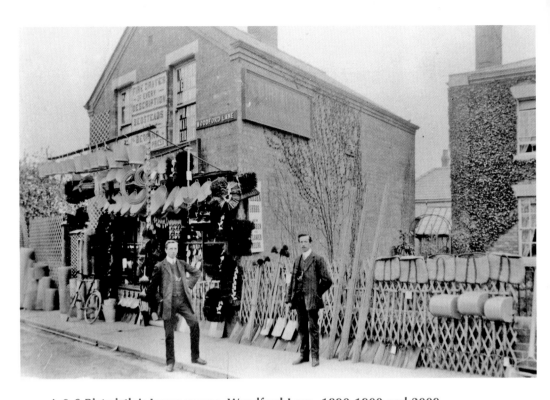

A & S Birtwistle's Ironmongers, Woodford Lane, 1890-1900 and 2009

This long established Winsford Company served the town well until very recently. It ended its days as a purveyor of Calor Gas and domestic appliances with the name R. Chesters & Co, another long standing Winsford Company name.

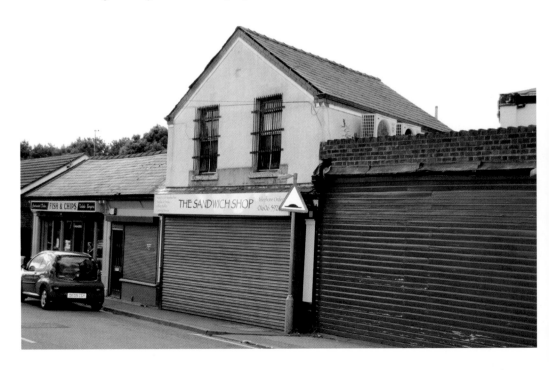

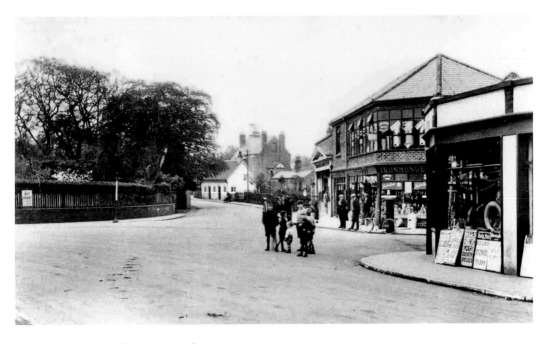

Four Lane Ends, 1920s and 2009

A view from Four Lane Ends, named because it is where High Street/Over Lane, Delamere Street, Swanlow Lane and Woodford Lane meet. The large house was the home of the Barton family before being replaced with a more modern one, the last resident then being the well-known magistrate Mrs Vera Barton. Behind the trees on the left the surgery of Dr Okel could be found, and the white cottage was demolished many years ago.

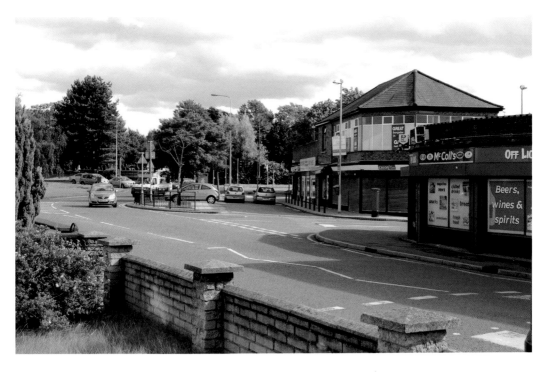

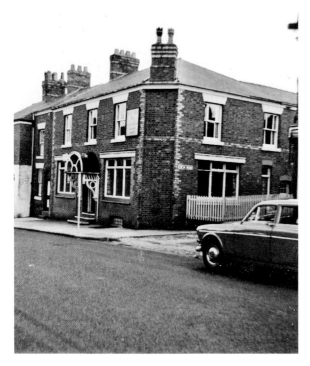

Bulls Head Pub, 1960s and 2009
This pub once stood at the junction with High Street and Geneva Road in what was a very busy part of the town. It was demolished in the late 1970s when that side of the road was cleared to make way for the new dual carriageway. Geneva Road was once called Factory Street when it led to Over Mills. The mills burnt down with the loss of eight lives, and the road name changed to Geneva Road, part of which still exists.

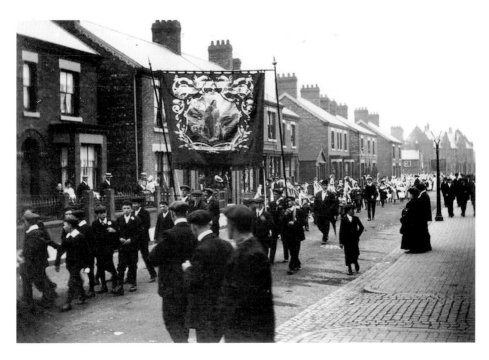

Upper High Street, 1910 and 2009

Another day and another parade, this time photographed from the opposite direction and showing what appears to be a church parade. The marchers are dressed in their Sunday finery so the ubiquitous flat cap is much in evidence on the men and starched collars on the boys, who also wear flat caps like their fathers. Note the small house set back with a white date plaque on the front wall and the two with similar plaques further down. A bit of a different view now!

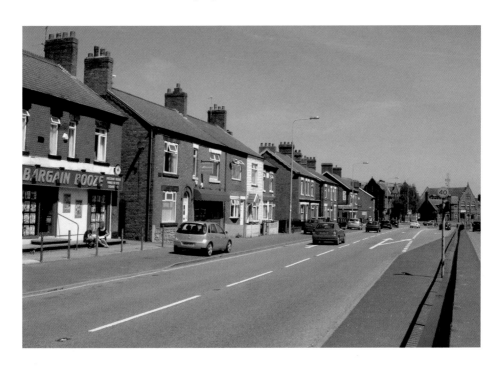

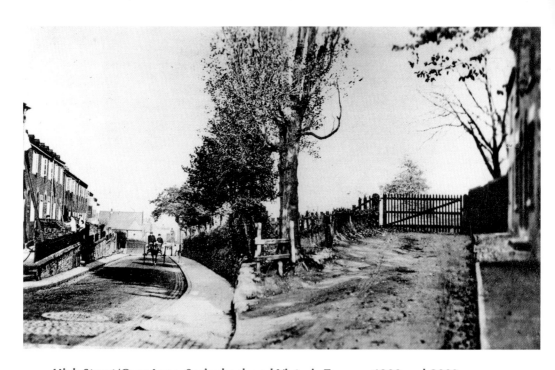

High Street/Over Lane, Springbank and Victoria Terrace, 1900 and 2009

The 1900 photograph shows the junction of Over Lane, now known as High Street, and the track leading into the fields at what is now Springbank. Over Lane is the ancient road that stretched from Delamere Street to the Town Bridge. The row of terraced cottages on the left is Victoria Terrace, now gone. It is now the route of the dual carriageway that splits the town in two.

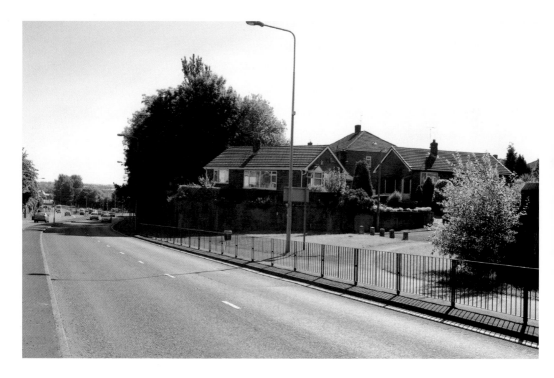

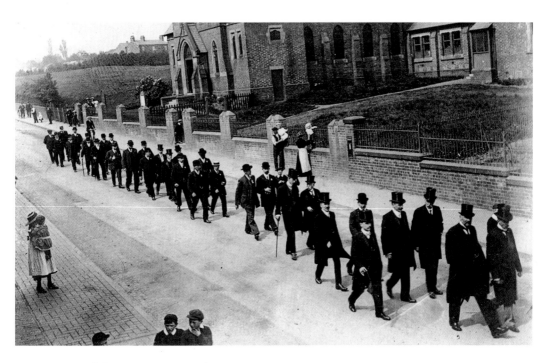

Upper High Street, 1908 and 2009
We see a parade of dignitaries march through the town, passing the Wesleyan Methodist chapel and the police station. High Street is now incorporated into the dual carriageway but in 1908 when the photo was taken it was a narrow road. The post box is still there although now not embedded in the wall, and the houses past the church are yet to be built.

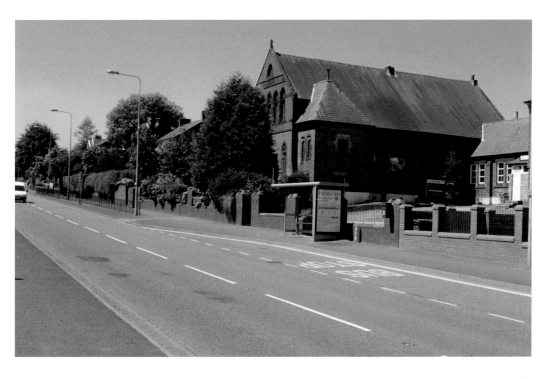

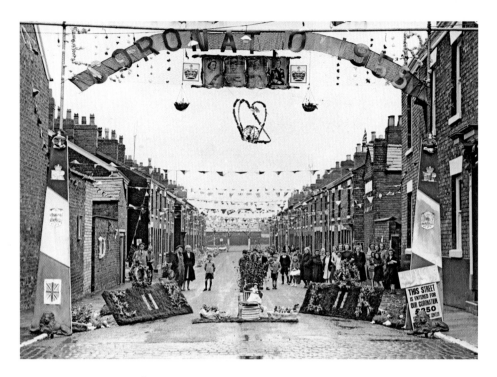

Dean Street, 1952 and 2009

Situated off the High Street, now the dual carriageway, this is one of a number of similar terraced streets in the area. At the other end of the street was The Spinners Arms pub, closed in 1935. This 1952 photograph has been wrongly marked as Dierden Street at Wharton. A quick perusal of the then and now photographs quickly identifies it as Dean Street during the coronation festivities of 1952.

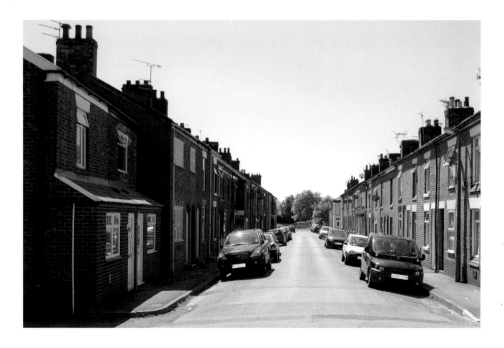

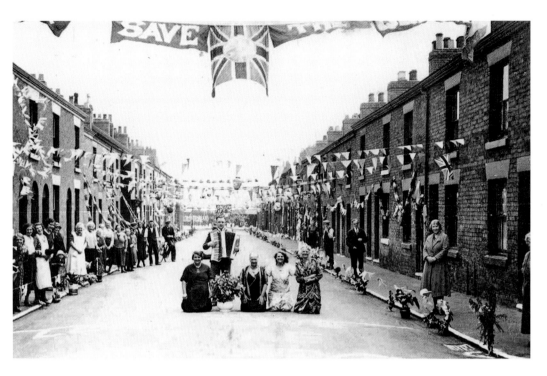

Dean Street, 1935 and 2009

Another shot of this well photographed street, this time during the street party for the coronation of Queen Elizabeth and King George IV in 1935. The photo is taken from further into the street. The chimney pots in the foreground have lasted well!

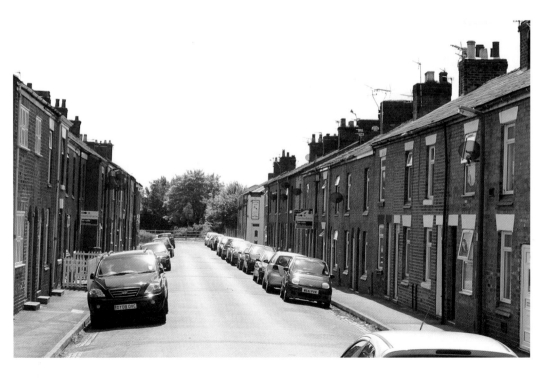

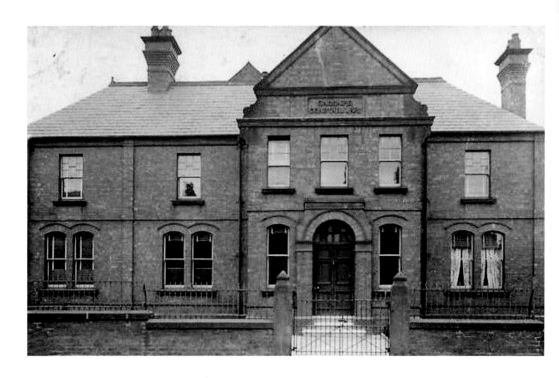

Winsford Police Station, 1890s and 2009

These two photographs show the difference over the years. Comparing the old photo with the new we see that there has been a further extension at the end. Curtains are in the right of the building as this was the house of the inspector. The original building was constructed in 1884 and the old photo was taken not long after. It was then Over Police Station and a smaller one was built in West Dudley Street to cover Wharton.

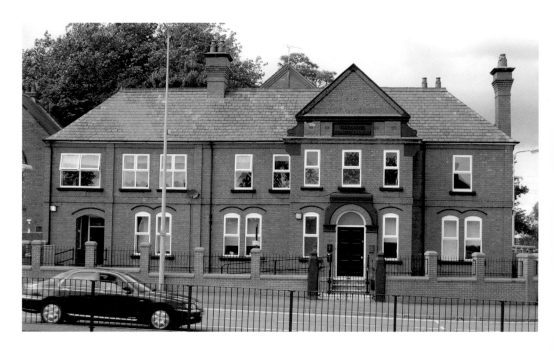

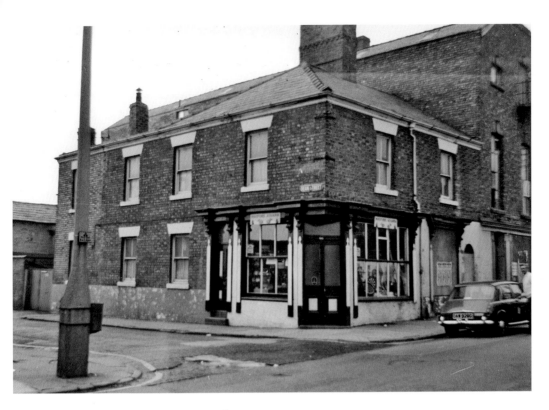

Corner of Dene Street, 1968 and 2009

A final look at the area, this time showing the end of the street before it was demolished to accommodate the dual carriageway. The corner building is a pet shop with a large factory next door. In the new photograph, the white lines in the centre of the road will be the location of the pavement edge in the 1968 one.

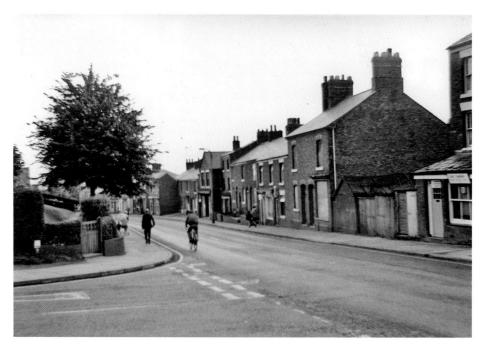

Moss Bank Junction, High Street, 1967 and 2009

In 1967 the old High Street was reaching the end of its long existence as Over Lane and High Street and within ten years it would be transformed (some would say, not for the better!) so enjoy these photographs showing the junction with Moss Bank then and now.

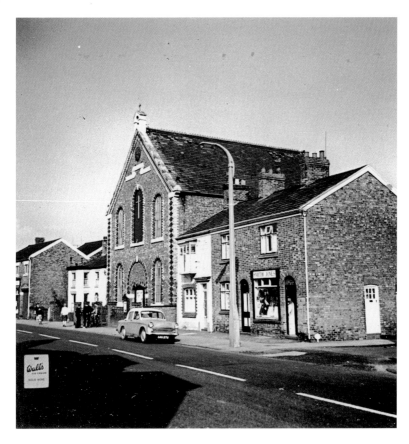

Central Methodist Chapel, 1960s and 2009

This chapel situated near to the junction with Dean Street was built in 1842 as the Central Methodist chapel on Chapel Street and then rebuilt in 1871 on the High Street. It was a Primitive Methodist chapel and was demolished in 1976 to make way for the dual carriageway.

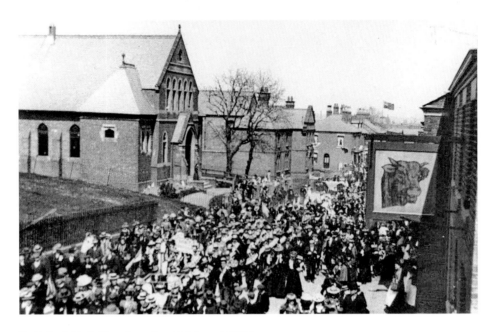

Relief of Mafeking Parade, 1900 and 2009

A favourite feature of Victorian and Edwardian life was the parade. Any reason would do and now we find a parade to celebrate the Relief of Mafeking. The photo was taken from an upper room in The Bulls Head pub opposite and shows the Methodist chapel and the police station which would have been quite new at the time. The building now houses flats and the town now has a new police station and the county police headquarters.

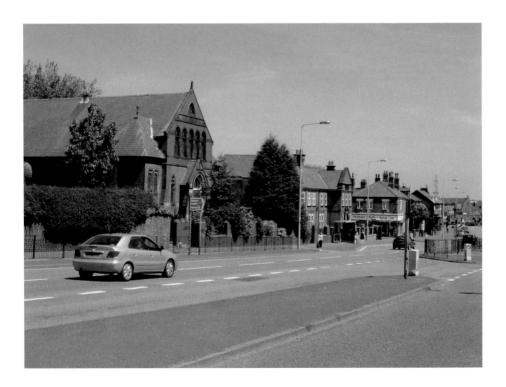

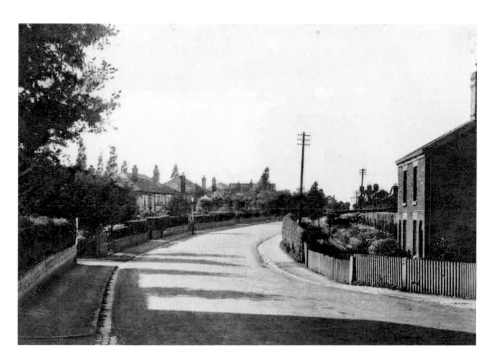

Grange Lane, 1920s and 2009

This deceptively long lane stretches from the High Street by the Verdin building all the way to Whitegate village. After passing Knights Grange it does become a little rugged, more suited to tractors than cars, but it is possible to get through – in a 4x4! Your eyes do not deceive you, in the new photograph on the right there is a man sitting with his feet down the chimney!

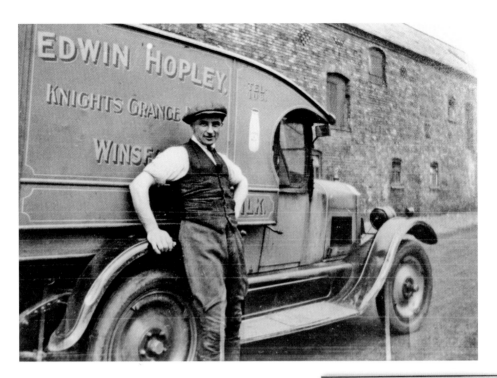

Knights Grange, 1920 and 2009

Once belonging to the monks of Vale Royal Abbey, Knights Grange farm is an ancient building dating from the sixteenth century and has been a pub since 1971. Before that its lands were purchased to build the Grange Estate. The old photo shows the farmer with his van outside the barn or shippon. This barn is now a function room. Modern milk floats are somewhat less attractive than the old van. The building itself once had a moat.

GRADE "A" MILK
Under Licence from the Ministry of Health

Obtainable from Exors. of

EDWIN HOPLEY

Knights Grange

Winsford

Tel. 3208 Winsford *Tel. 3208 Winsford*

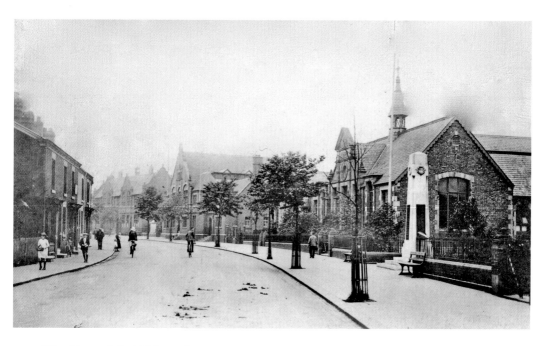

War Memorial, 1920s and 2009

This area has changed dramatically through the years but the main red brick buildings still stand proud. The war memorial remembering the dead of previous wars will have been quite new when this photo was taken. It was unveiled by Colonel Sir George Dixon, chairman of Cheshire County Council, 18 September 1920. It now stands in the town centre after suffering vandalism in the 1970s.

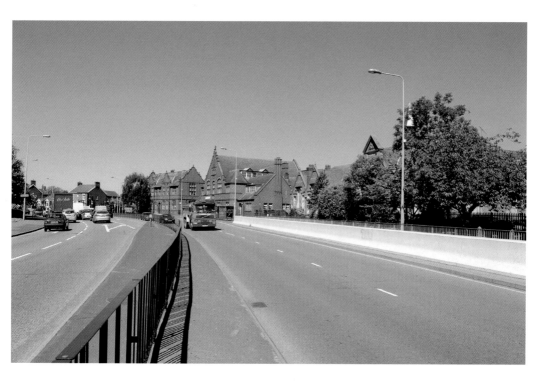

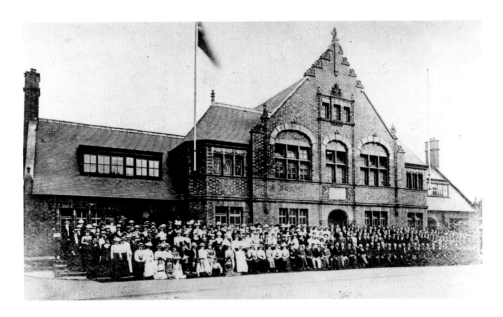

Verdin Technical Schools, High Street, 1910-20 and 2009

The Verdin Trust was set up in 1889 by Sir Joseph Verdin to compensate people for subsidence caused by brine pumping. In 1891 the Brine Pumping Compensation Act was passed thereby rendering the trust redundant. The money was used to build the Verdin Technical Schools, opened in 1895. They were later extended and became Winsford Verdin Grammar School and are now part of the Mid Cheshire College of Further Education and the Verdin Exchange. Adult Education and small businesses occupy the premises.

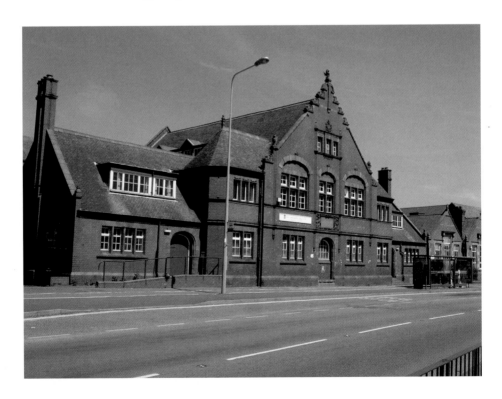

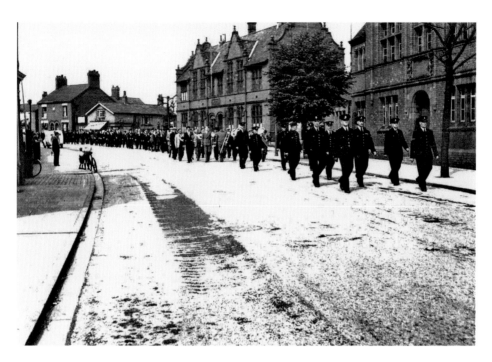

Mayor's Procession, 1950 and 2009

Here we see the Mayor's Procession led by a police contingent passing the Brunner Guildhall and Verdin Exchange. The Guildhall was opened in 1899 as a Diamond Jubilee gift to the town from Sir John Brunner. It now houses the Citizens Advice Bureau together with assorted other offices and meeting rooms. It is a beautiful building created in Jacobean style with a red terracotta front elevation.

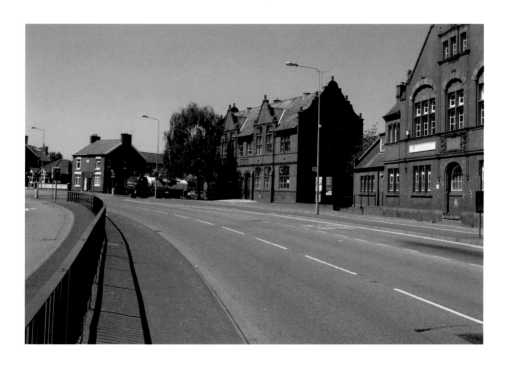

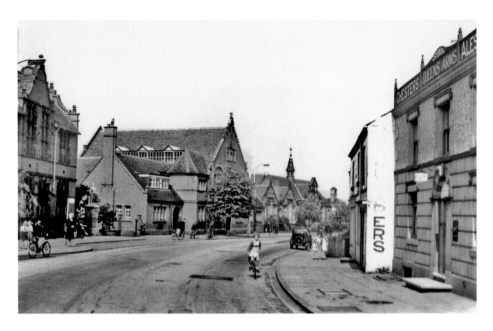

Winsford Guildhall and Schools, 1950 and 2009

In the 1950s photo we see a young girl riding her bike past The Queens pub, it would be a far more hazardous activity today! The Queens was demolished with the rest of that side of the street and a new larger pub called The Queens Arms, which is now a Weatherspoon's pub, was built around the corner in Dene Drive. On the other side of the road things are virtually the same despite the sixty years in between.

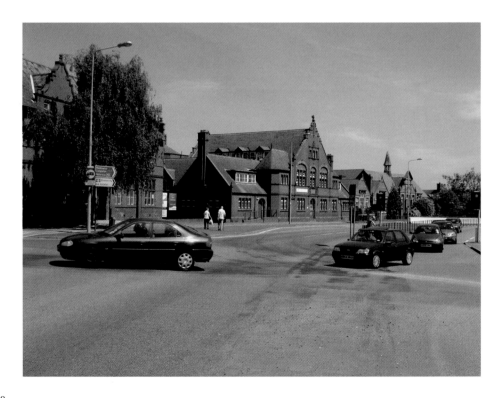

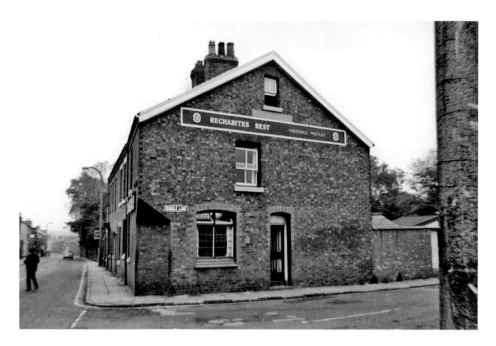

The Rechabites Rest, 1968 and 2009

During Victorian times temperance was a virtue. Drink caused many problems and temperance organisations were popular. One such organisation called The Rechabites, named themselves after the people in The Book of Jeremiah and strict teetotallers. The pub was opened in 1871 and was situated at the end of a row of terraced cottages at the junction of High Street and Dingle Lane. It was closed in 1973 and demolished some time later. Giving that name to a pub would now be thought of as cynical!

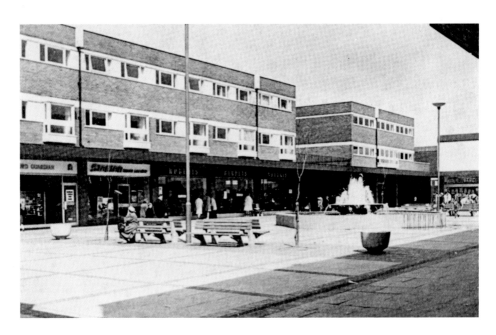

Winsford Shopping Centre, 1960s and 2009

In 1961 the decision was made to make Winsford a new town and work was started on the estates and shopping centre. This is the result of the latter, designed by one of Britain's leading architects. The 'Precinct' was part completed when the photograph was taken. The end building on the right in the 1960s photo is the Co-operative department store, which is now Bon Marche.

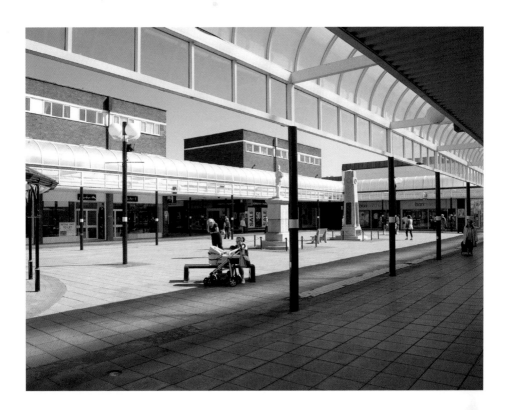

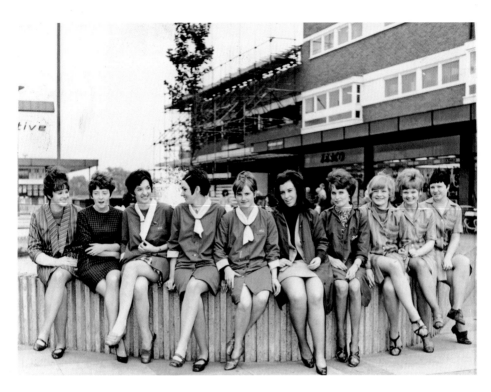

Precinct Shop Girls, 1960s and 2009

This is a photo of a selection of shop girls who worked in the new shopping centre. It was so new that it is still being built and has only reached the Co-op store, now Bon Marche. They are sitting on the fountain in Fountain Court. The fountain has now gone as a bit of wind caused shoppers to get wet and children put soap in it for a laugh!

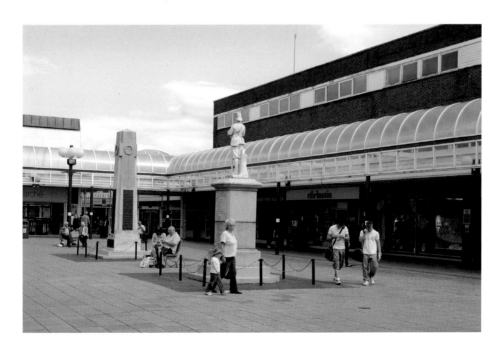

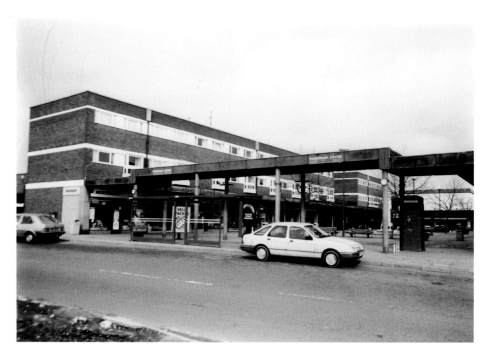

Fountain Court, 1980s and 2009

A last look at the Precinct, now Winsford Cross shopping centre, this time taken outside from The Queens pub opposite, taken in the 1980s. Not so long ago, but a lot of change has taken place. This transformation is mainly due to the change of ownership from the council to a private company and the bleak windswept precinct has been changed into something far more pleasing on the eye! As we go to press, permission has been given to demolish most of the shops and rebuild them!

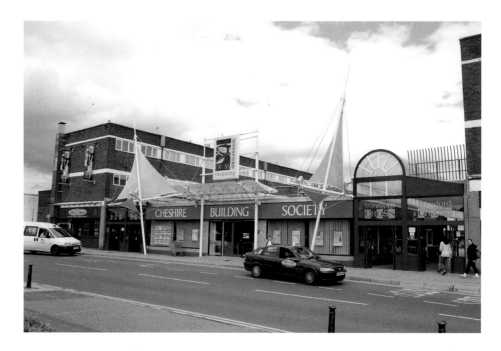

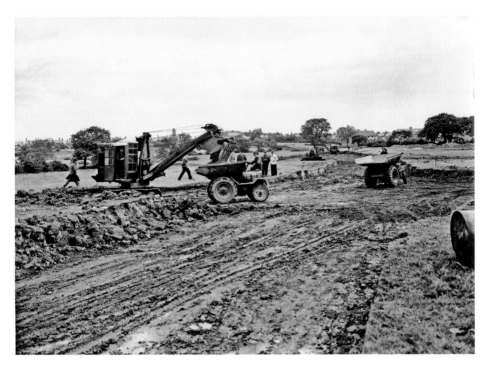

Queensway Dene Drive Junction, 1946 and 2009

In 1944 it was decided to build houses on large estates. The first of these was the Dene Estate, which was opened 24 July 1946. The old photo shows work under way on the crossroads. The plan was that a small shopping area would be provided on this cross roads, hence the larger gardens with room for access roads. This was later changed and houses built.

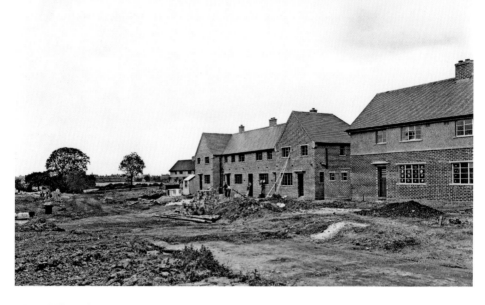

Churchill Parkway, 1946 and 2009

A further look at the post war building of the Dene Estate, which was a superbly built council estate with substantial houses and large gardens. What a shame that this build quality could not be maintained in some of the town's estates that were to follow it. The houses shown are in Churchill Parkway and the builders W.E. Noden.

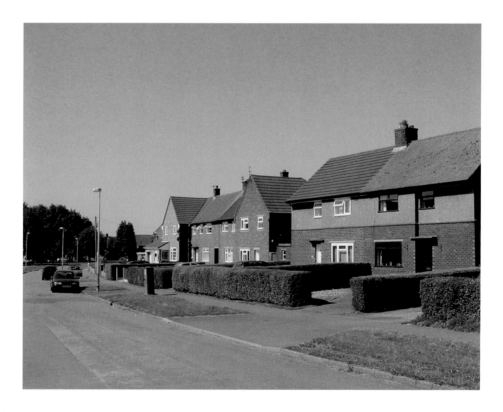

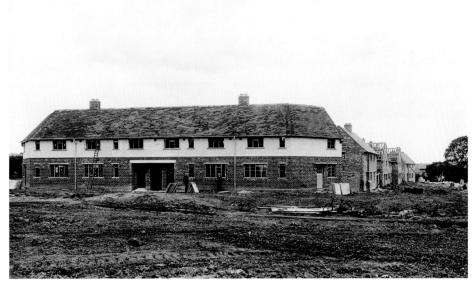

Churchill Parkway Junction, Dunkirk Avenue, 1946 and 2009

These houses built by the contractors Wilson & Harrison show the varying styles used to break up the estate and give a contrasting vista. The opening ceremony was on 24 July 1946 when the house used was No. 3 Alamein Drive. Councillor Arthur Breeze performed the ceremony. The Chartered Engineer and surveyor for the estate was P. Heaton who gave his name to Heaton Square.

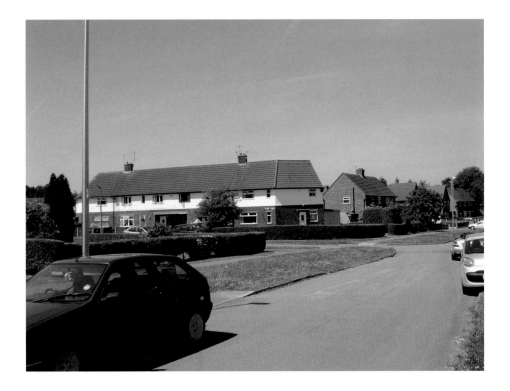

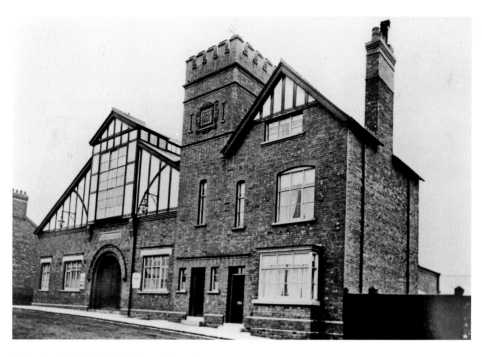

Winsford Drill Hall, 1900-10 and 2009

Built as The Volunteer Drill Hall and opened in June 1901 by Lieutenant-General the Earl of Dundonald. It was used in 1914 by a detachment of E Co. 7th Territorial Force Battalion, Cheshire Regiment under Captain J.K. Cooke and Sergeant-Instructor Walter Nutting. After the First World War the building became the Palace Cinema and by 2009 it had become a bingo hall.

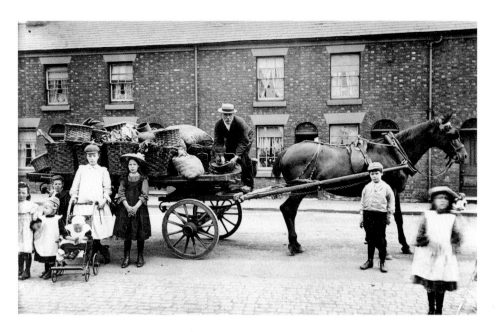

Ways Green, 1900 to 1915 and 2009

This street is a continuation of Dingle Lane and leads to Stocks Hill and the Winsford Flashes and now the Winsford Sailing Club. In Ways Green was Fern Villa an imposing house, now the Conservative Club. The old photograph was taken from the junction with Granville Street, now leading to Granville Square. The greengrocer on his lorry is weighing out vegetables on the scales, presumably for one of the children. The photographer has intervened to freeze this tableau for posterity.

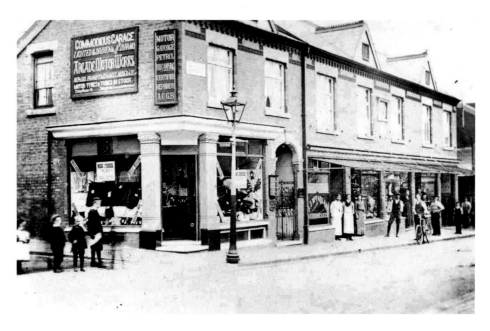

Corner of Siddorn Street, 1910 to 1920 and 2009

The building on the corner of Siddorn Street and the High Street is known as Stubbs Chambers. There is an arcade at the side leading into a garage premises in Siddorn Street. The shop with the men in white aprons is James Joseph McFarlane Hairdressers at 106 High Street. The business on the corner carries adverts for the Arcade Motor Works and its 'Commodious Garage'. A car repair business is still in being in these premises. The shop itself appears to be an outfitters.

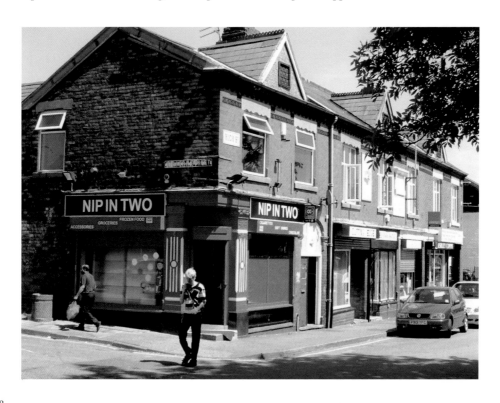

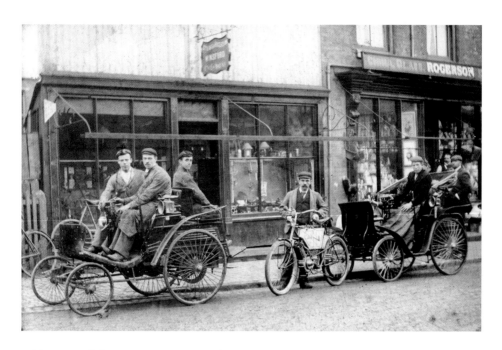

Old Cars, High Street, 1895-05 and 2009

This old photograph is of what must have been some of the very first motorcars in Winsford. They are pictured in the High Street outside what is now High Street Garage. When the photo was taken it was Stubbs and Rogerson Cycle Works, the shop next door is Rogerson's China and Glass Dealer. This shop went on to house Harris Furniture, Auto Spares and now the strangely named Livvy's Tom Baby World!

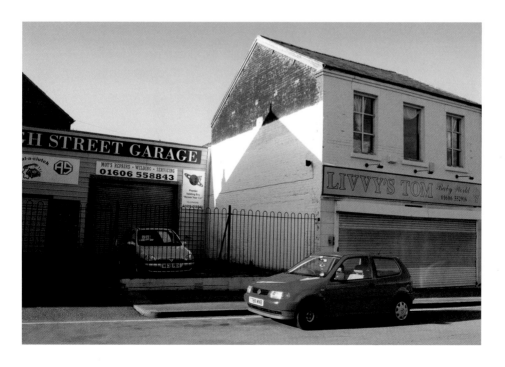

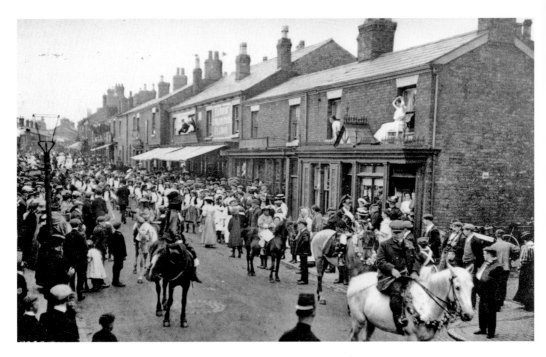

Hospital Saturday Procession, High Street, 1905 and 2009

In 1898 the Albert Infirmary opened in what was Highfield House, the home of the Verdin family before they moved to Darnhall Hall. The Hospital Saturday procession was an annual charity event to raise money for the infirmary. The shop that the ladies are sitting on the top of was Eliza Hulse's milliner's shop. The road at the side is Bakers Lane, which once led to open country and salt workings.

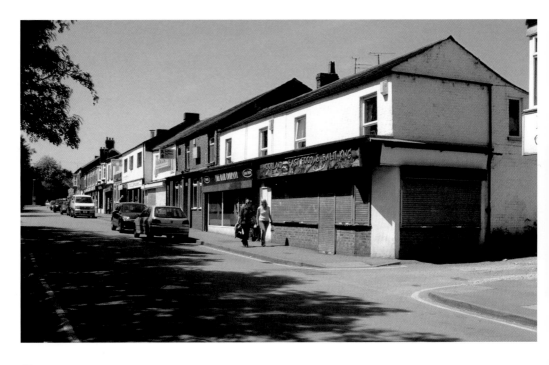

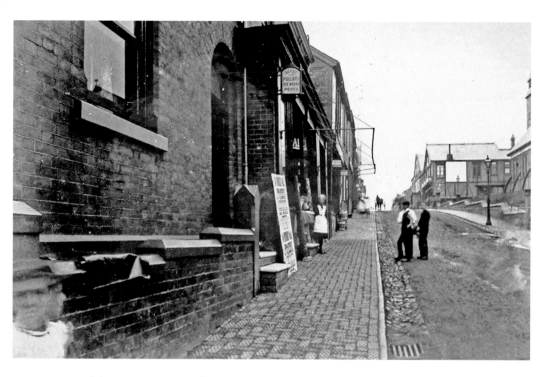

Lower High Street, 1892 and 2009

This early photograph was taken from the bottom of the High Street in roughly the area where the dual carriageway underpass now starts. The buildings consisted of a well-built terrace of houses and shops. Across the road was Christ Church, known as the Waterman's church. Both the buildings on the left and the church went in the 1970s. The first large building on the right ended its days as Pimlotts antique shop and was derelict for many years before demolition in the new millennium.

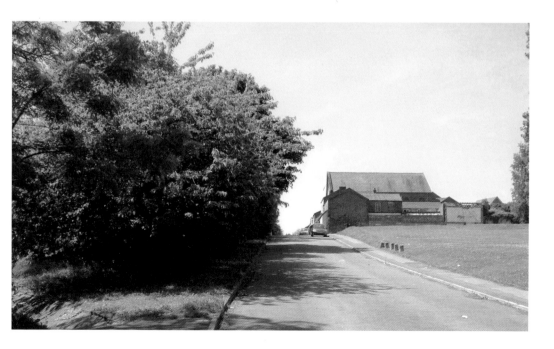

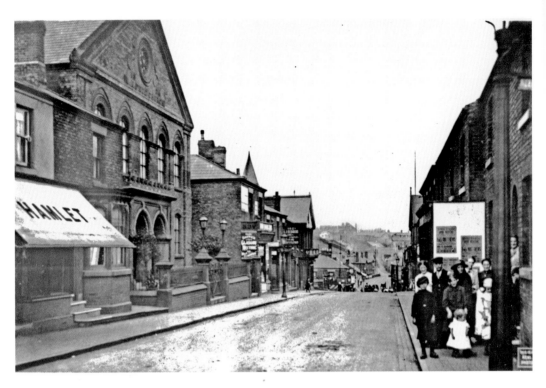

High Street by United Methodist Church, 1810 and 2009

Looking down the High Street towards the Town Bridge and beyond we see the large St Paul's Methodist chapel, formally the United Methodist chapel, on the left. Rebuilt in 1877 this imposing building was closed 100 years later and is now a carpet showroom.

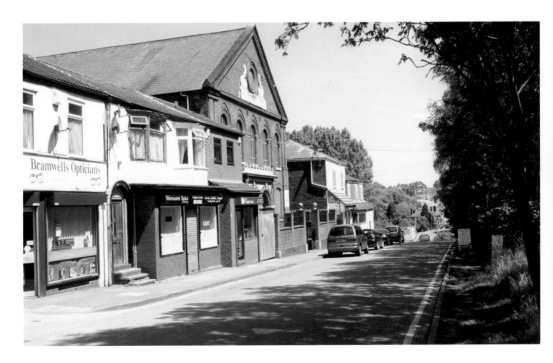

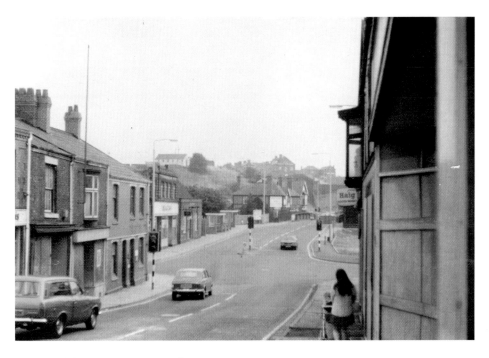

Lower High Street, 1970s and 2009

A last look at what was soon to be completely swept away; within a few years all the buildings on both sides of the road would be gone. All that is left on this side of the Town Bridge in 2009 is the old post office building that spent a short while as a chip shop and has now been derelict for some time. The old High Street is still the main A54 and the bridge carries traffic in both directions.

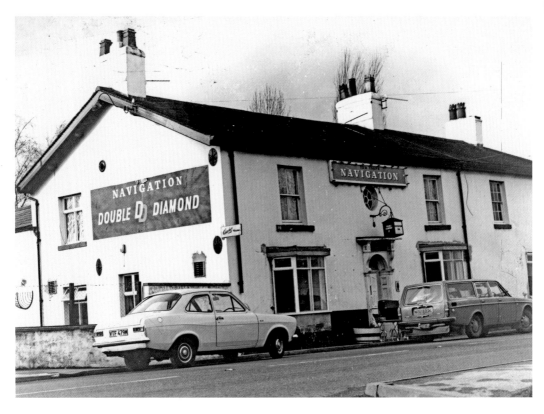

Navigation, 1970s and 2009

Around the corner from the old High Street are New Road and the nightclub once known as The Liquid Lounge. This is now closed and semi derelict awaiting redevelopment. Once The Navigation Inn and then The Vale Royal it suffered from subsidence to such an extent that it was demolished in 1989 and rebuilt in 1990. In the days before mega-rich footballers, the licensee from 1928 to 1934 was John Brittleton who had played football for Winsford United, Stockport County, Sheffield Wednesday, Stoke City and England!

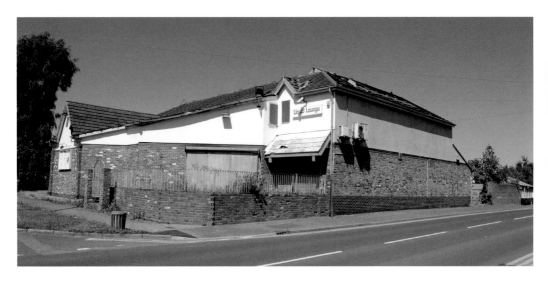

Meadow Bank Schools, 1890s and 2009

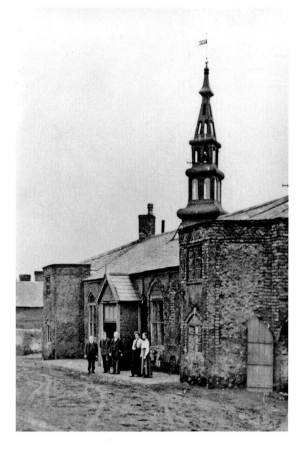

Continuing along New Road towards Meadow Bank one would pass the bass houses built by the German salt baron Herman Falk who imported Polish, Hungarian and German workers to work the salt pans. The houses were in streets called Castle Terrace and Bass Row opposite the works. They, like the school, were built of bass, a waste cinder like product of the furnaces. This area was truly foul and overcrowded to such an extent that the last cholera epidemic in Cheshire was in the 1860s at Meadow Bank.

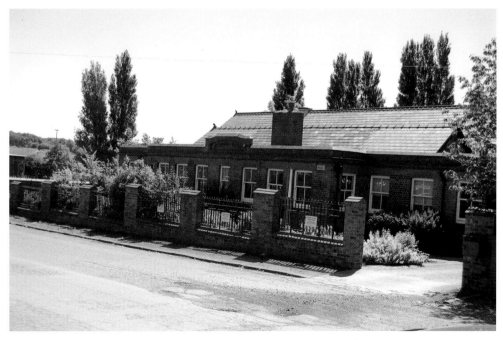

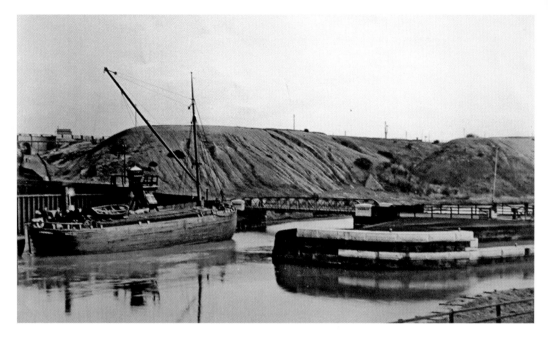

New Bridge Salt Works, 1900 and 2009

Once a busy scene of salt workings, and boats passing through the locks on the way to Liverpool, this area was once dirty and dark. It was the site of the New Bridge salt works. On passing through the lock towards Winsford the boats, some of which were built in the town, would enter a stretch of the river that cut a murky swathe through the myriad of salt works belching sulphuric smoke day and night. Across the locks was and is a shortcut to the village of Moulton through tunnels under the railway.

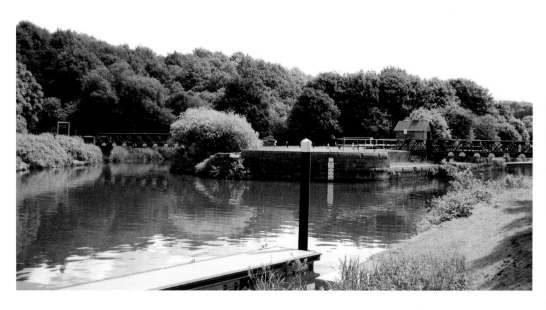

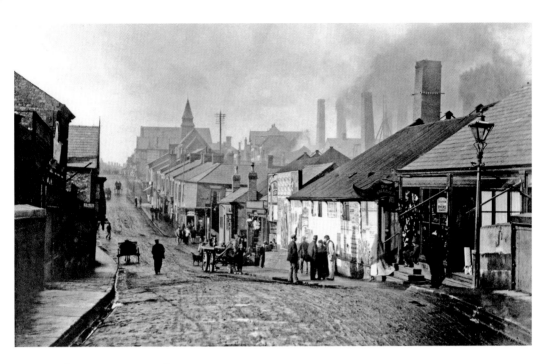

Dark Town, 1890s and 2009

The old photograph gives an insight into the awful conditions that existed in Winsford in the 1800s and 1900s and why it was nicknamed 'Dark Town'. The photograph taken from the Town Bridge gives some idea of what the residents of this part of the town lived through. The smoking chimneys stretched all along New Road to Meadow Bank. But the 2009 photograph is of green trees and blue sky, something that the people of this area seldom saw.

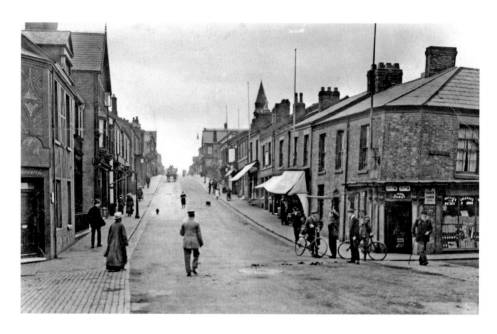

High Street, 1900 to 1910 and 2009

A photo taken of the bottom of the High Street at the junction with Weaver Street and New Road, all of these buildings have now been swept away. The area on the left has been grassed over and on the right trees where once stood a thriving community mask the dual carriageway.

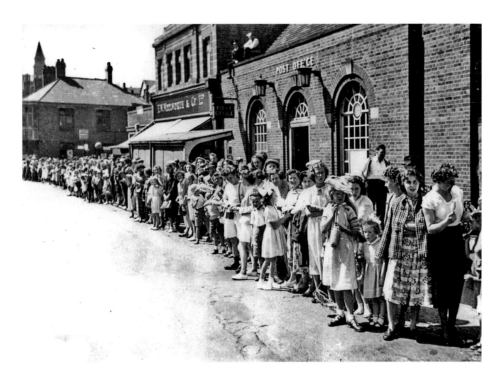

Outside the Post Office on Carnival Day, 1952 and 2009

Next to the post office stands F.W. Woolworth, little has changed in the area other than it is somewhat cleaner. The onlookers await the arrival of the carnival procession in 1952; a brave postman and his friend have climbed on to the roof for a better view. In the modern photo, things are a little sad. Woolworths has gone and the post office is abandoned and derelict.

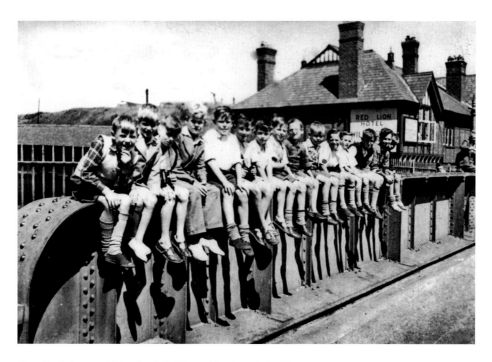

Carnival day on Winsford Bridge, 1952 and 2009

Another look at the 1952 carnival, this time of a group of schoolboys sitting on the bridge smiling for the camera and awaiting the procession, after it has passed they will make their way to the carnival ground to watch the crowning of the Rose Queen. After that it's to the fair where the music of the day will boom from the rides.

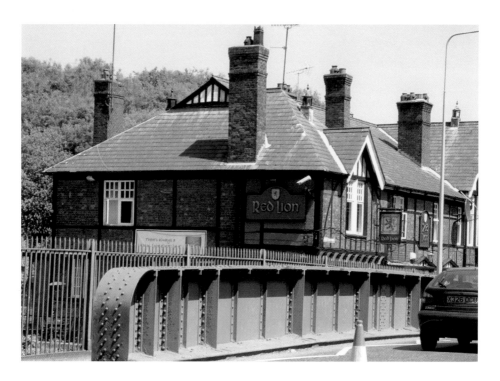

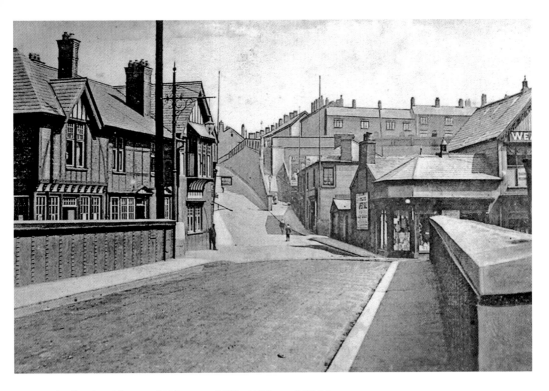

Winsford Bridge and Wharton Hill, 1890 and 2009

The old photograph has been carefully touched up before selling as a postcard and shows the retaining wall and the houses in Hill Top Avenue above. The new photograph shows just how much change there has been.

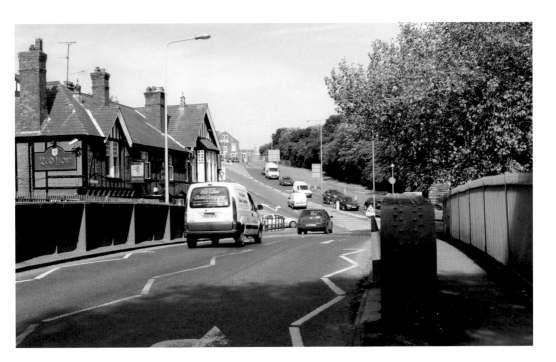

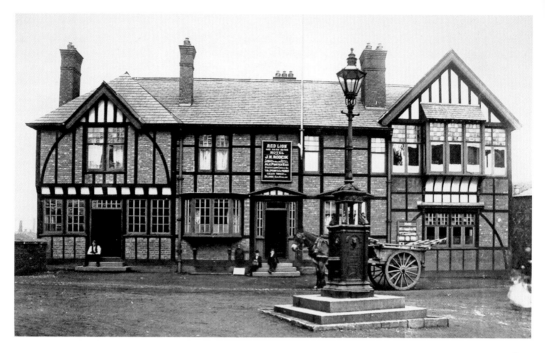

The Red Lion Public House, 1890 and 2009

The Red Lion is the oldest pub in the town, and the first landlord, James Staley, served his customers in 1767. Some would say, however, that the pub is the only one in Winsford! Those on its left are in Over and those on its right and in front are in Wharton. Whatever the truth, the pub dominated the old Market Place. If only the pub could talk, what a story it would have to tell!

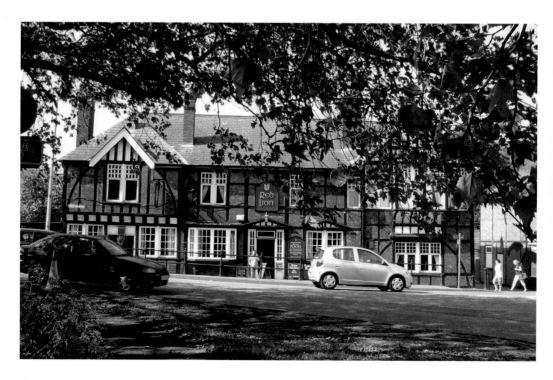

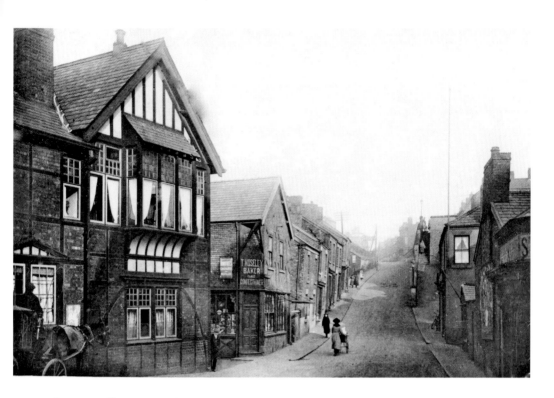

Wharton Hill, 1890 and 2009

Sometimes called Winsford Hill, sometimes Wharton Hill this road from the Town Bridge to Northwich was at one time built up and busy. The more famous Winsford Hill is the one in Winsford, Somerset, so Wharton Hill is the more appropriate. The lady with her pram would not be able to push it up the road in 2009, not safely anyway.

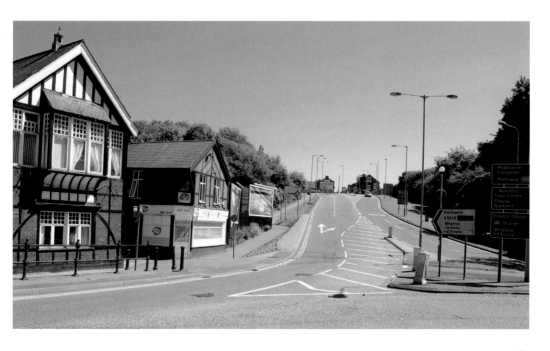

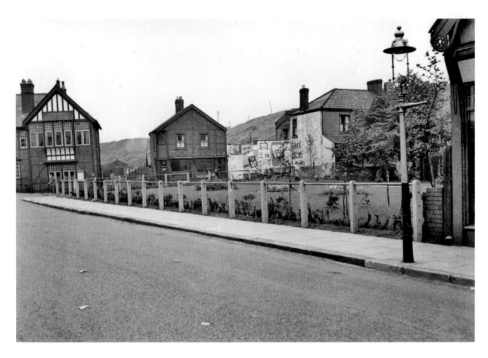

Market Place, 1949 and 2009

Looking out of Market Place towards the Red Lion and Wharton Hill in 1949 we see that a lot of the buildings have been removed. The advertising hoarding has the rather politically incorrect slogan 'Tea's up, ease up, smoke Bar One cigarettes!' The modern advertisement is for Carling lager and the building is a pizza takeaway. There are also cones in the road as the road markings on the roundabout are being upgraded after many complaints.

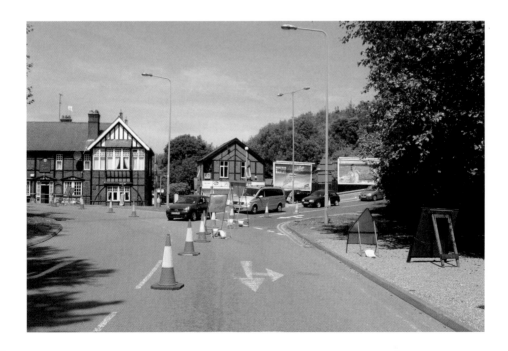

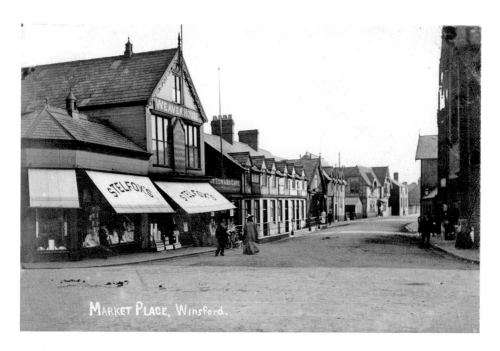

Market Place, 1890-1910 and 2009

The building on the extreme right is the town hall with The Royal Oak and The Ark in the centre. Winsford's Red Light District at the turn of the last century! The terraced building on the left houses three pubs, The Ship, The Flatman's Cabin and The Coach and Horses. The smartly dressed lady in the old photo would have left the area by nightfall and one or two 'ladies of the night' would have taken her place.

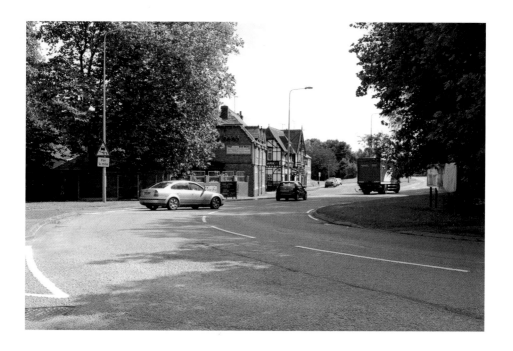

Station Road Numbers 13-15 and 17, 1892 and 2009

The large house bears the name Baths Villas and at the time of taking the old photo it was quite new, having been built in 1889. It bears this title as it stood opposite Winsford Baths, which at the time were situated there. Most of the houses in the area suffered the effects of subsidence and were demolished, and the baths burnt down.

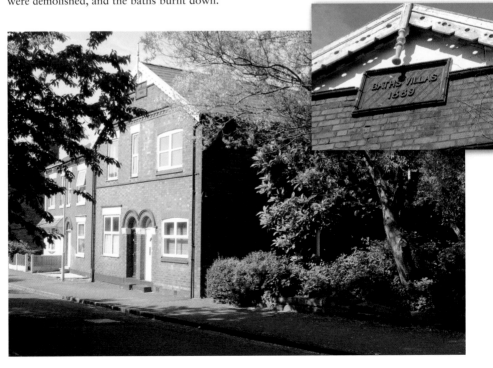

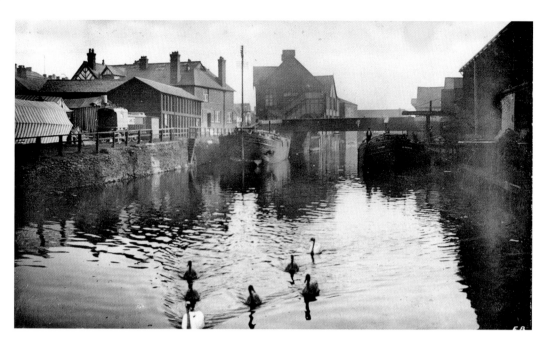

Towards the Town Bridge, 1905 and 2009

In this old photo we see a swan and her cygnets swimming away from the Town Bridge towards Northwich, the town hall with its staircase on the outside of the building. An evocative shot showing the rear of The Red Lion and two salt boats loading, the man watching the photographer from one of them may, if the boats remained long enough, enjoy the nightlife nearby.

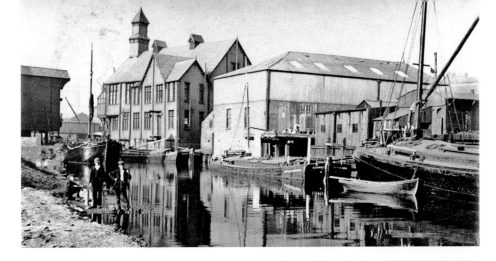

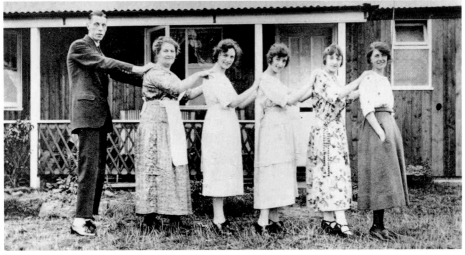

Dockyard and Town Hall, 1905 and 2009

Here we look back towards the old Town Bridge and Market Place, known at the time as Crosse's Dockyard. This was as far as large boats could navigate and beyond the bridge are Winsford Flashes, upper and lower. These occurred after subsidence caused by brine pumping and were put to good use as a boating lake called The Cheshire Broads. They now boast the Winsford Sailing Club and a caravan site.

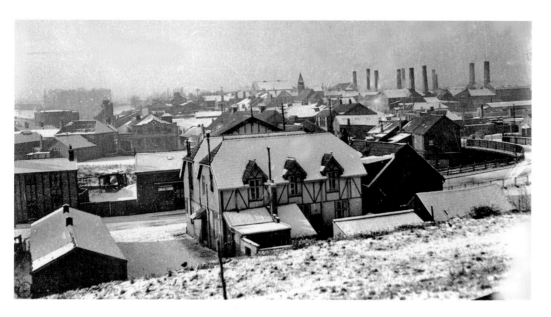

Market Place from Hill Top Avenue during the 1950s

We are now looking down at the backs of The Ark and De.bees and across lower Winsford. The snow has made the area deceptively clean but the chimneys in the background are pumping out their acrid smoke – and this is as late as 1950! I have aimed my shot over towards the Ark, otherwise only trees would be seen. The Town Bridge and the spire of the Waterman's church are in the distance.

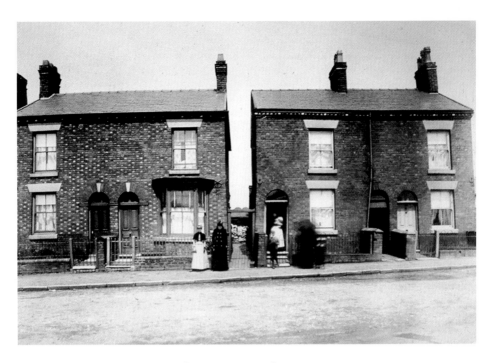

Station Road 99, 101, 103 and 105, 1892 and 2009

This row of houses was situated at the top of the brow, known as Gravel Hill. From Bath's Villas to here on Station Road all of the houses were cleared due to subsidence. In the later photo a more modern house from around the thirties that replaced them can be seen.

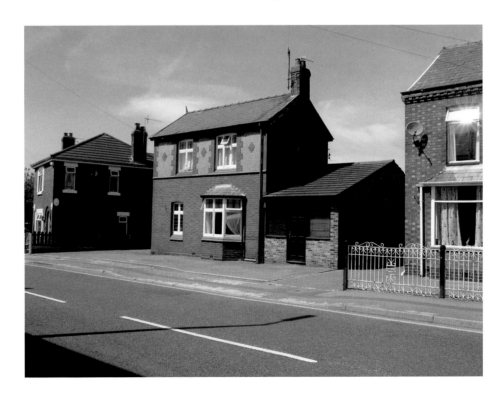

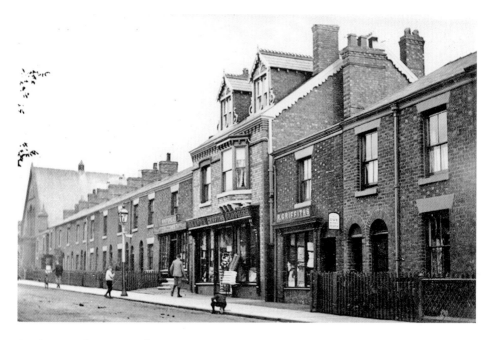

Station Road, 1916 and 2009

This road used to be called Gravel Lane during the 1800s and the name changed after the station was built at the top during that century. The view in the 1916 photo is towards the station and the large building on the left with the roof windows is Griffith Draper and Clothier, now a late shop. Further up is the Trinity Methodist church, which in this 1916 photo has a porch and the front elevation has been remodelled. In an older photo the church has no porch.

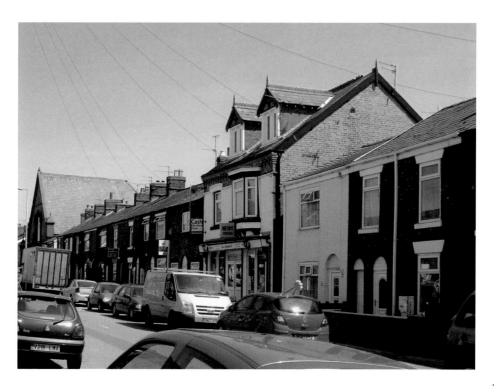

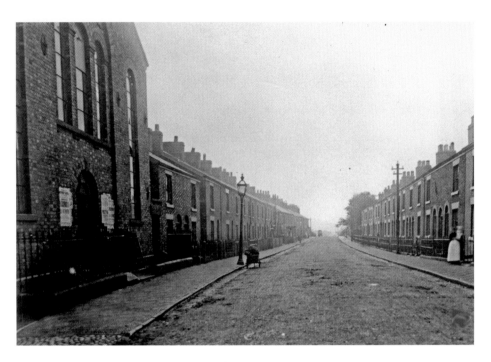

Station Road Looking West, 1891 and 2009

We now have an 1891 view in the opposite direction; in this view the large building with the roof windows is not shown. There is, however, work in progress in that vicinity and the Trinity Methodist church has no porch. The history of the church shows that it was built in Crook Lane in 1831 and rebuilt in 1865 on Gravel Lane (now Station Road). This had to be demolished due to subsidence and a new chapel was built on the same site and opened in 1893. So we have the answer!

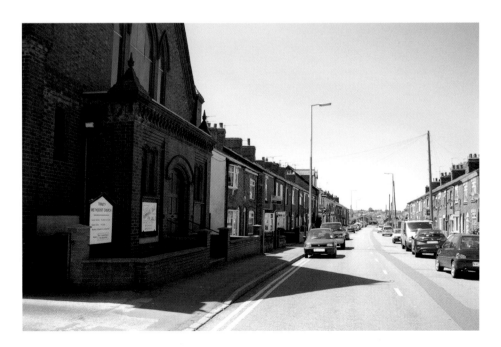

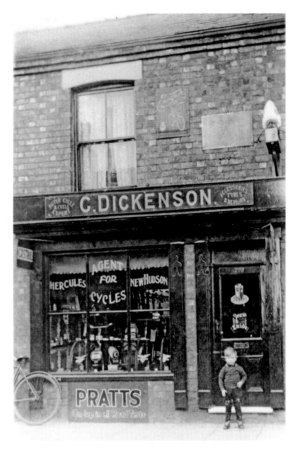

Cliff Dickenson, 1928 and 2009

This old established business – one of the oldest in the town – has been situated in Station Road since 1928. Like most car dealers it started its life selling pedal cycles and progressed through motorcycles to cars. Expanding into nearby premises and with a large workshop it remained in the same family; the young boy shown in the doorway is Ken Dickenson, the grandfather of the current owners. The business is not to be mistaken with Dickinson Brothers, who started life in Winsford in 1918 but closed the doors for the last time some years ago.

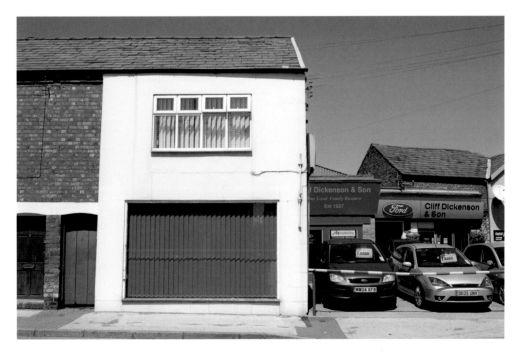

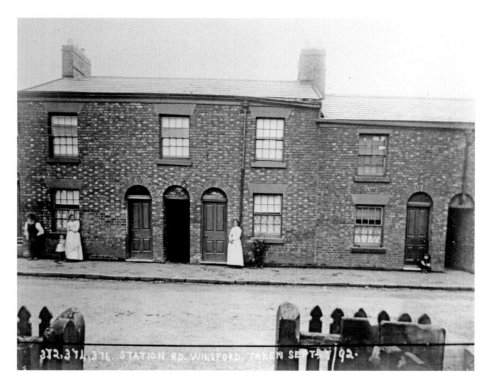

Station Road 372 to 376, 1892 and 2009

Just a look at how things have changed – or not – through the years. These terraced houses in Station Road have gone through cosmetic change but have remained, externally anyway, as they were over 100 years ago.

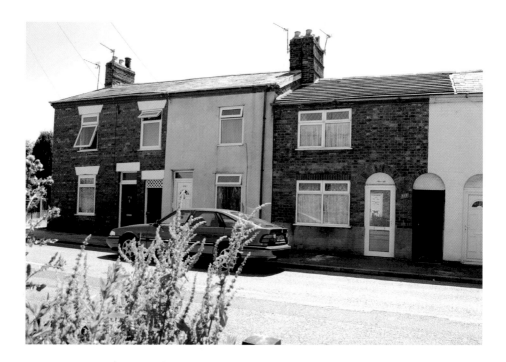

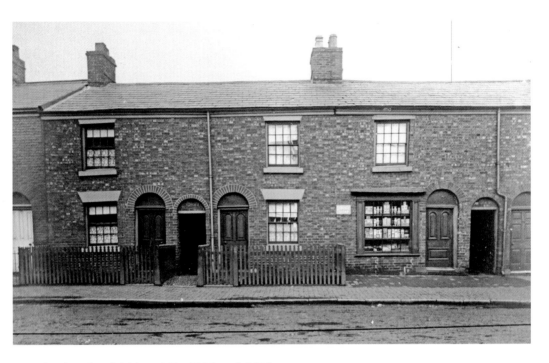

Station Road 261 to 267, 1891 and 2009

Another look at this terraced street but on the opposite side of the road, No. 265 is a shop with a display of vases and boxes in the window. On the wall there is an advertisement for Sunlight Soap and by 2009 the shop has closed and the locals have to go to one of the supermarkets for their soap! It has now become a dwelling house, and the house on the end of the row has gone.

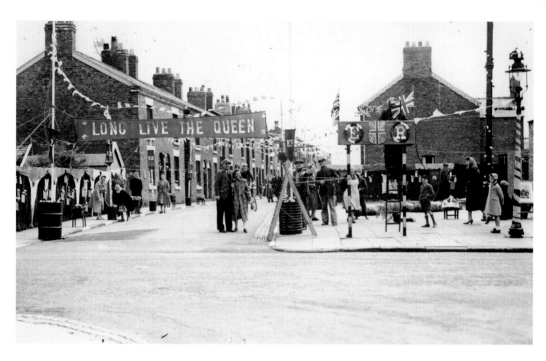

Dierden Street, 1952 and 2009

This short street situated towards the top of Station Road is seen in the 1952 photograph enjoying a street party to celebrate the coronation of Queen Elizabeth in 1952. No doubt the pub on the corner, the Oddfellows Arms will have supplied the refreshment.

Station Road Nos. 317 to 321, 1892 and 2009

In the 1892 photograph we see the shop of S. Hulse Grocer with terraced houses numbered 317 to 321. In the modern photo these buildings have gone and a branch of the Winsford Industrial Co-operative Society has been built in 1902, with a space left where once the cottages were.

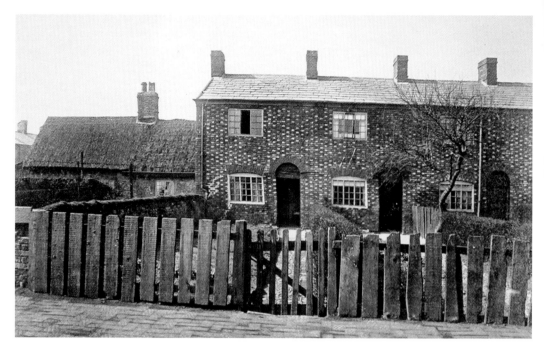

Crook Lane Nos 1 to 7 in 1892 and 2009

Across the road from Dierden Street is Crook Lane with this row of terraced cottages. In the older photo there is a thatched cottage at the rear but by 2009 this had been replaced by a narrow detached house. These ancient cottages were once the only dwellings in the road.

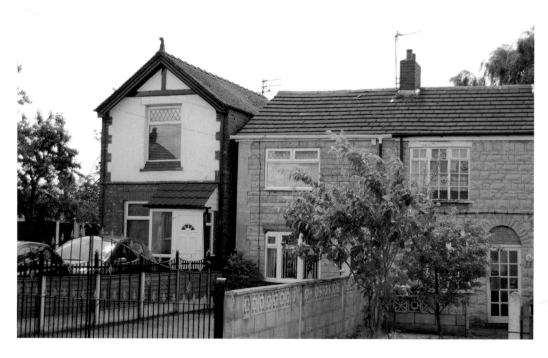

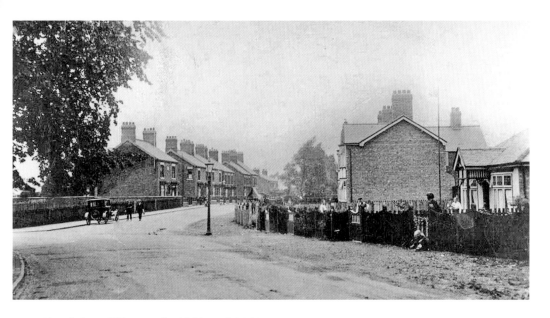

Crook Lane Wharton in 1923 and 2009

We now walk along Crook Lane, once known as Crooked Lane because of the bend shown in the photographs, and we come to Wharton church. In the 1923 photograph the photographer has set up his equipment there. The neighbours, intrigued by his actions, come out to watch as he captures for posterity this snapshot in time. The birthplace of Baron Bradbury of Winsford is just behind the camera in the 2009 shot and bears a commemorative plaque on the wall.

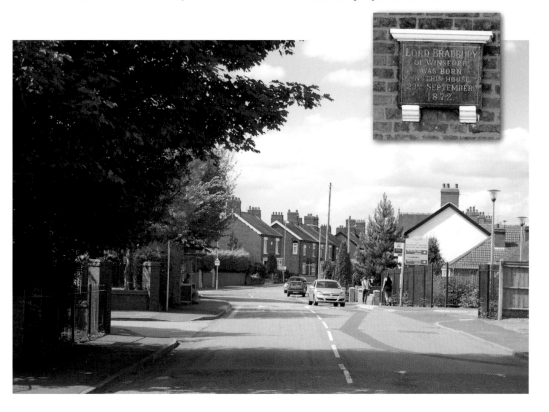

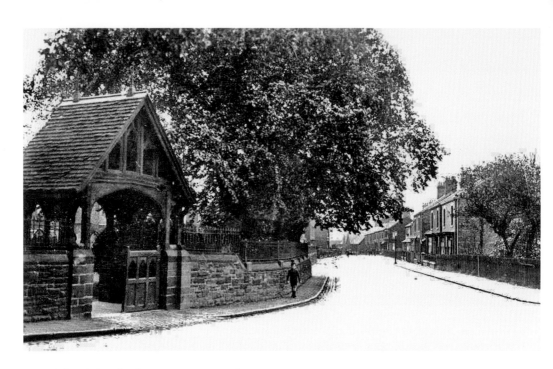

School Road Wharton, 1920s and 2009

Once the main street in Wharton village, which before the building of the church in 1849 was in the parish of Davenham, School Road has changed little. The Wharton schools that can be seen in the far distance have gone, taking half of the building structure with them.

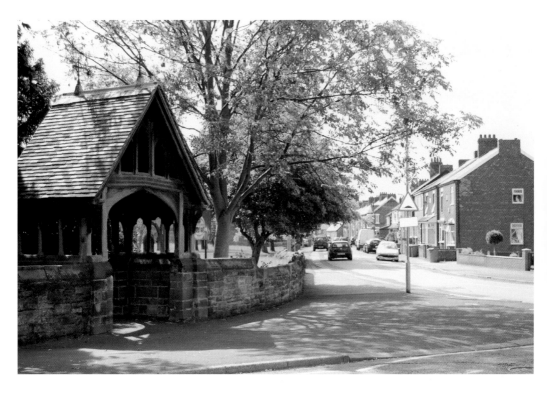

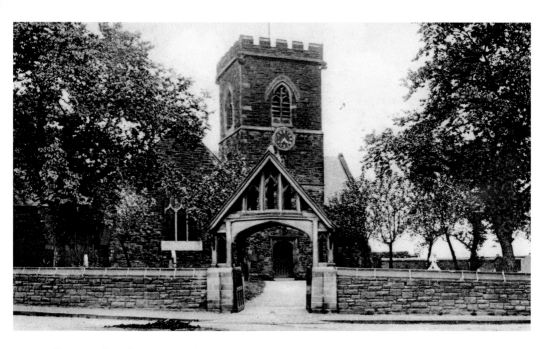

Wharton Church, 1903 and 2009

Until 1835 Wharton had no church of its own and in that year a chapel of ease was constructed near to what is now Wharton Railway Bridge. This had to be demolished when the railway was built and work started on the church shown in the photographs. It was consecrated by the Bishop of Chester on 26 June 1843 but was not completed until 1849 when it also became independent from Davenham.

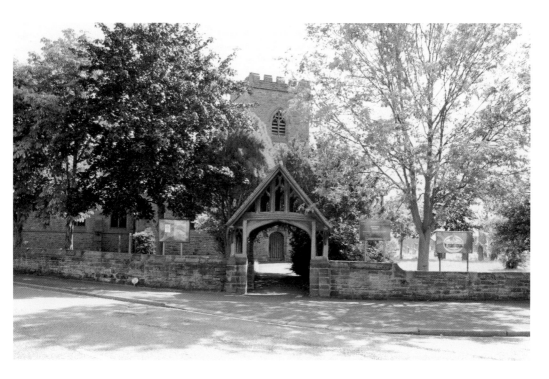

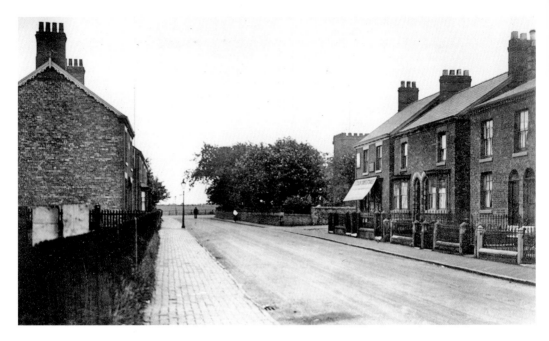

Wharton Village by the Church, 1914 and 2009

The maelstrom that was to become known as The Great War was about to be unleashed and would take the young men of both Wharton and every other village, but in this 1914 photo all is peace and harmony in School Road. Nothing has yet been built on the other side of Crook Lane and all the way to Bostock Road was farmland known as the 'Clapaches' or 'Claps' where in 1908 an infamous murder had taken place.

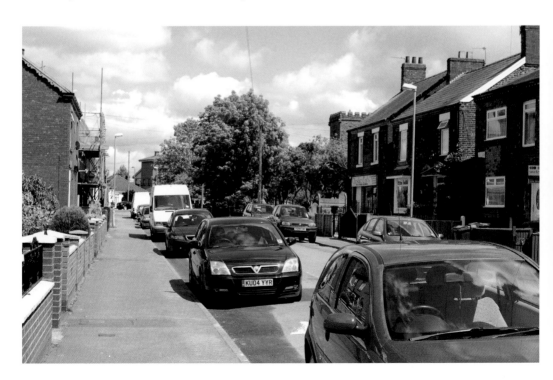

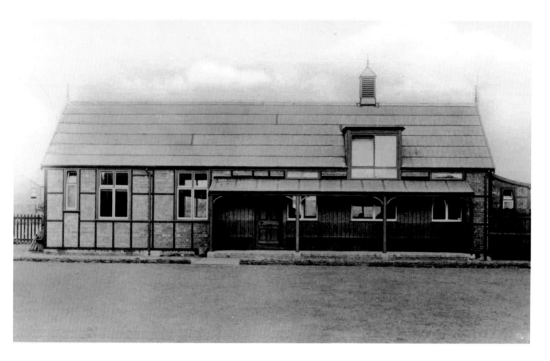

Wharton Conservative Club, Undated and 2009

With the address of 34 School Road, the Wharton Conservative Club sits between Wharton Road and School Road with access from both. It was photographed when new in the first half of the last century and the bowling green was opened by the prospective Conservative candidate for Northwich, Jersey de Knoop of Calveley Hall. Because of the corrugated iron roof it was nicknamed the 'Tin Mission' and that name has stuck with it through the years.

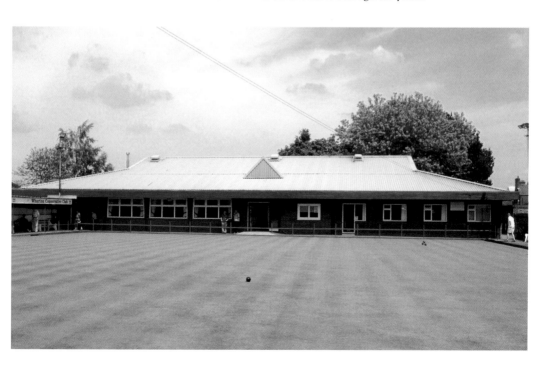

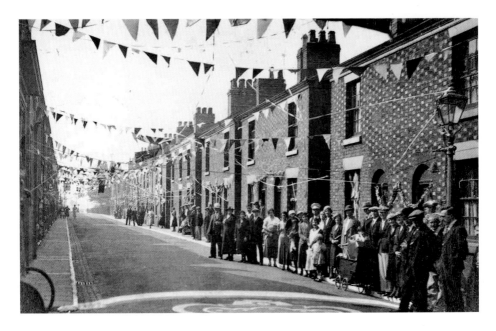

Ledward Street, 1935 and 2009

Situated at the bottom of School Road, Ledward Street was one of the terraced streets in the area built to house salt workers. The early photograph shows bunting and decorations to celebrate the Silver Jubilee of George V. The street led through from Wharton Road to Station Road and housed one of the first Co-op stores.

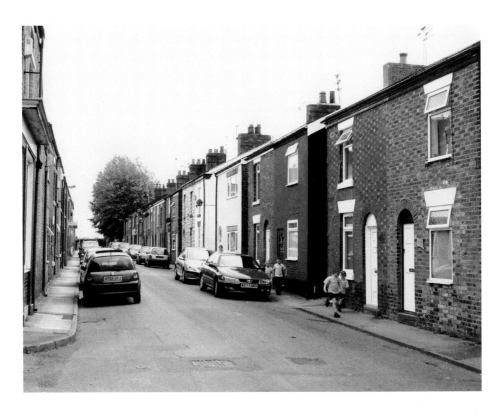

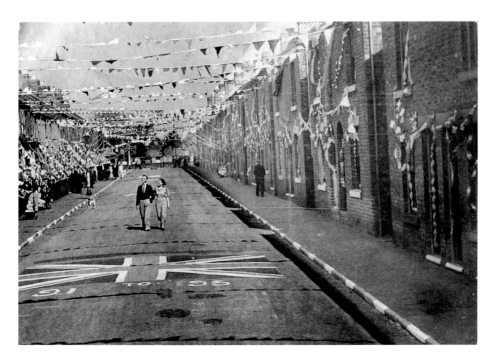

Princess Street, 1935 and 2009

I have included this photo as it is such an atmospheric one but it has me slightly baffled. It is marked Princess Street 1935, which was the date of the Kings Silver Jubilee, but I think that it is wrong. The dress is more 40s/50s and I deduce that it could be an end of the Second World War photo, perhaps welcoming home a serviceman or servicemen. The writing on the road is easily seen but what does it mean? Reader, it's over to you, I may be wrong!

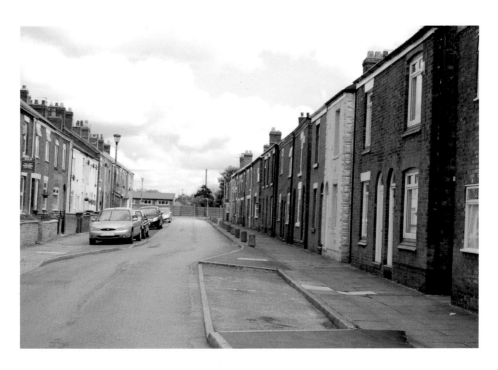

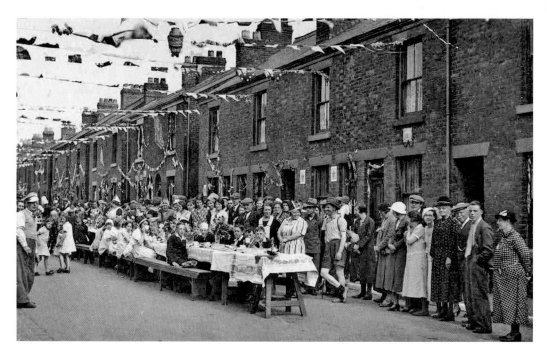

Princess Street Jubilee Tea, 11 May 1935 and 2009

No dispute here, this street party like the one in Ledward Street is to celebrate the Silver Jubilee of George V. Who at that party could have foreseen that just a few months later in January 1936 King George would die leaving Prince Edward to take over the crown? Or that Edward would abdicate after a year throwing the country into a constitutional crisis? In this old photograph, however, a good time is being had by all and community spirit is alive and well.

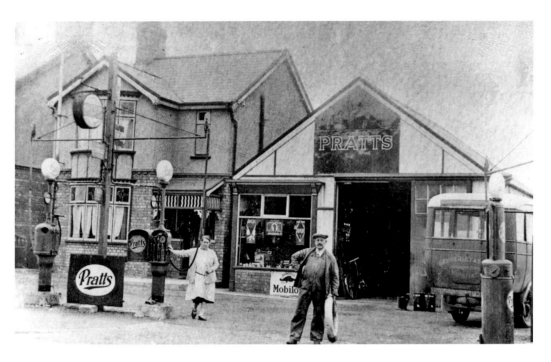

Curzon's Garage, Wharton Road, 1930s and 2009

This garage was situated opposite East Dudley Street and was a garage premises/petrol station almost into the new millennium. It was then removed to build the access road called Eden Avenue leading into a new private estate. In the old photograph Mr Ernest Curzon stands on the forecourt probably at the request of the photographer. To the right a rather scruffy bus owned by Kennerley & Son awaits attention.

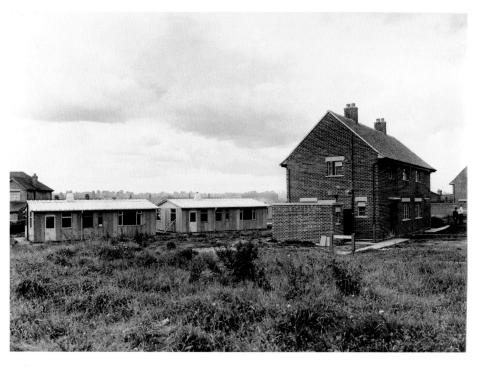

Kingsway, 1949 and 2009

This small estate at the top of Wharton Hill was started before the war and completed after it. Prior to the house building pre-fabs existed, as can be seen in the older photo, and some remained in use into the 1970s. This house looks over the Barton Stadium car park and since being built in around 1949 it has acquired an extension to the far end.

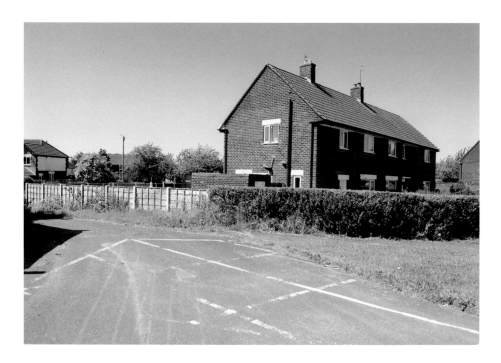

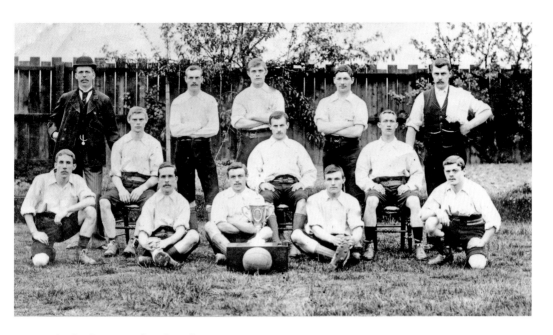

Winsford FA, Undated and 2008

Winsford United FC has existed since 1883, originally known as Over Wanderers until 1902. Although undated I would estimate that the old photo was taken during the 1920/21 season when they were the Cheshire County League champions (they were founder members of the league). During the 2006/07 season they were North West Counties League Division Two champions (on goal difference) and were promoted to Division One, which has now been renamed the Premier Division.

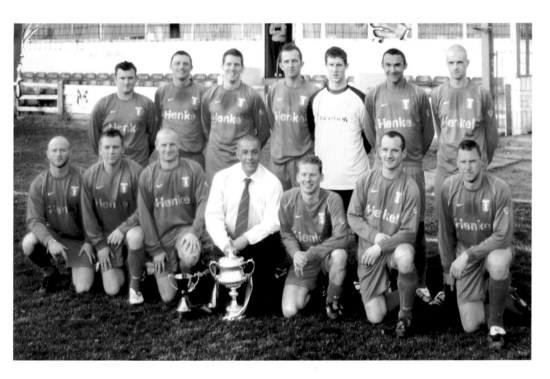

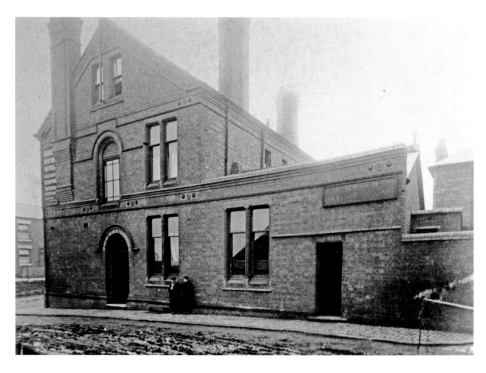

North Western, 1892 and 2009

Almost new when photographed in 1892, the pub stands at the top of Wharton Hill. In the new photograph a low wall can be seen on the other side of the road. This is built with stone sleepers that were used experimentally by the LNWR; there are others in the garden of Winsford station. During the 1980s Harold Hine had been a regular for sixty years and always referred to the pub in his old Winsford dialect as 'Th Top Ayse'. The name was duly changed to The Top House.

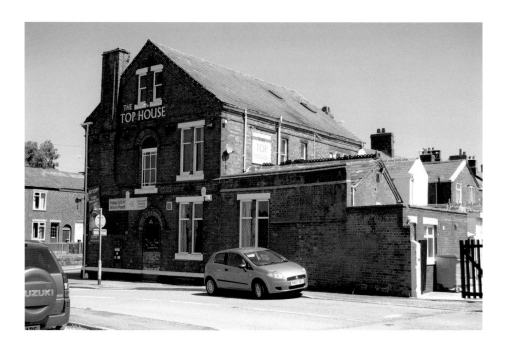

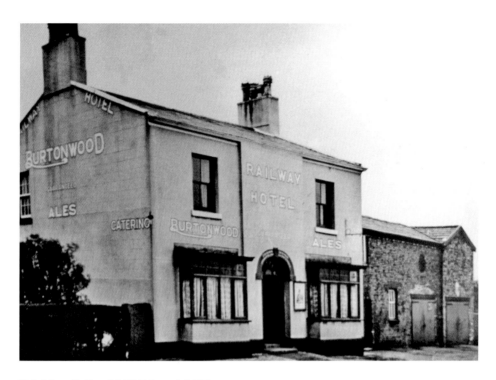

Brighton Belle, 1900/10 and 2009

Prior to 1841 this was a farmhouse with a barn. Like most pubs built or adapted to serve the railway, it was called The Railway Hotel and was opened as such in 1841. It held this name until 1972 when a carriage called Mona from the opulent electric train service The Brighton Belle was attached to the side and used as a restaurant, the name being changed at this time to The Brighton Belle.

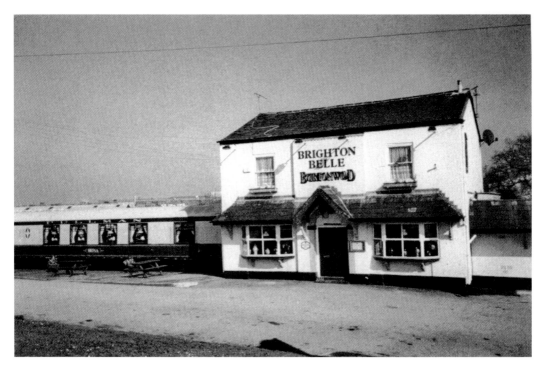

Brighton Belle, 1972 and 2009

A look at the pub with the carriage in situ. When the pub's name was changed to The Brighton Belle, Winsford gained an instant tourist attraction. For the next twenty-six years this was a popular and novel pub-restaurant but eventually time took its toll and it started to deteriorate. In 1998 it was taken away and refurbished for use back on the railway, attached to a classic train.

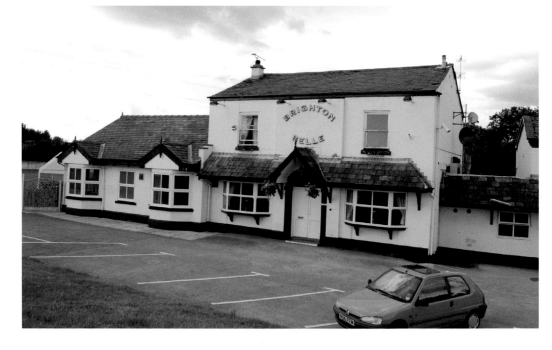

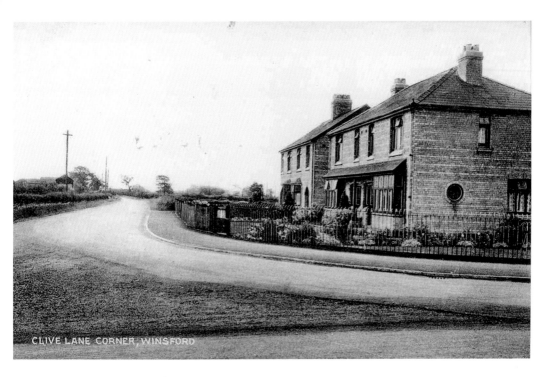

CLIVE LANE CORNER, WINSFORD

Clive Lane, 1930s and 2009

This old road leads from the junction with Middlewich Road and Road One through to the Middlewich/Nantwich road. A short way into it is Clive Back Lane that runs parallel with Station Road. Near to the West Coast Main Line it has seen a few train crashes over the years, notably one where a soldier pulled the communication cord to stop the train in Winsford causing a crash with loss of life.

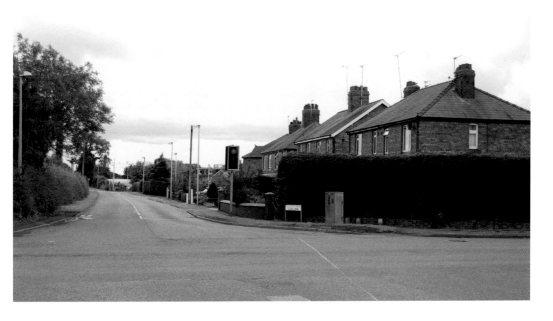

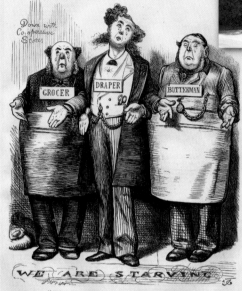

FUN.—June 4, 1879.

"VICTIMS OF CO-OPERATION."
A PATHETIC APPEAL.

Clive Co-op Opening, 1879-1936 and 2009

In 1860 Winsford Industrial Co-operative Society was formed and quickly became the main shopping experience for most people. The old photo shows the opening of the Clive branch in Middlewich Road in 1936. When a new organisation – as now with out of town supermarkets – people accused it of taking business from the high street shops. I have included here a satirical joke from the *Fun Magazine* of 4 June 1879 highlighting this – nothing changes!

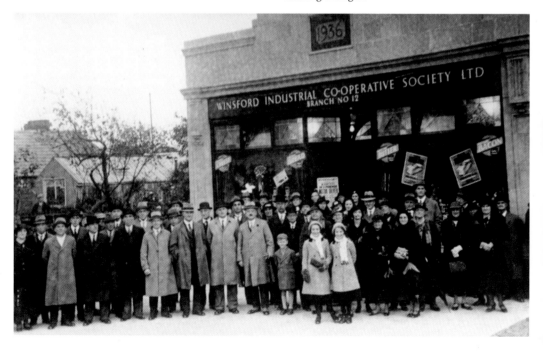

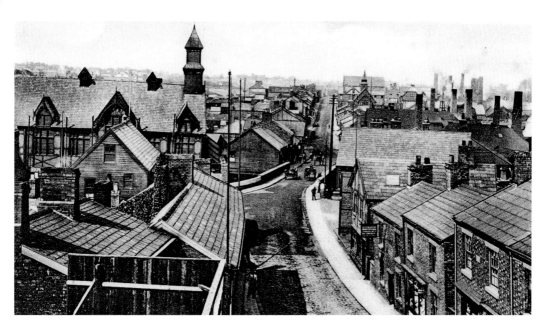

Wharton Hill, 1903 and 2009

A look down Wharton Hill in 1903 and another in 2009 ably highlights just how this area has changed over the years. Once the busiest part of the town it has now been relegated to a through road.

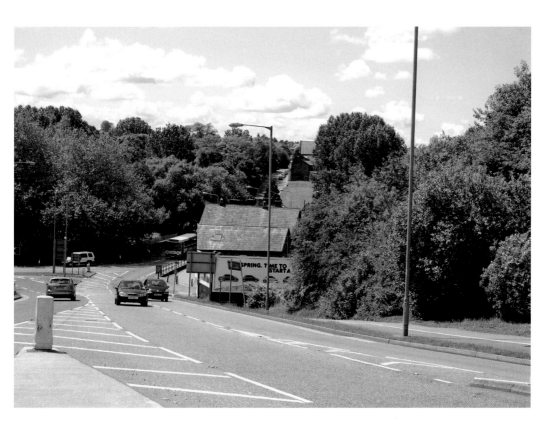

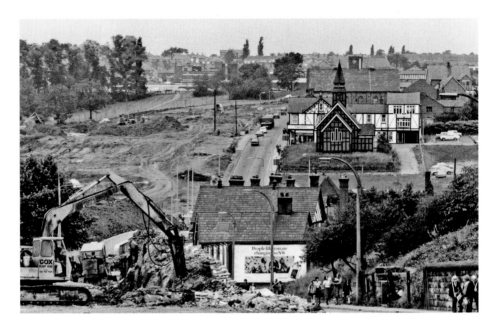

Wharton Hill, 1970s and 2009

From the previous photograph of the area to this, we see how the change came about. The building of the new dual carriageway is on going and Wharton Hill is being widened. The plan to drive this dual carriageway straight through the centre of the old town was quite contentious and the plans for a 'large parkland to stretch along the banks of the Weaver with clubs, hotels and a sports centre on a Marina Development' never did come to fruition by 1986 as promised at the time!

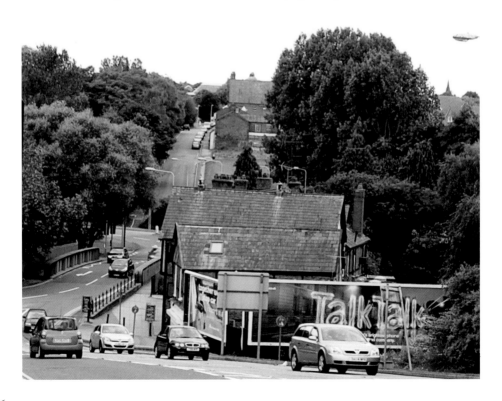